IMAGES
of America

SPRINGFIELD
VOLUME II

IMAGES
of America

SPRINGFIELD
VOLUME II

Ginger Cruickshank

ARCADIA

First printed in 2000.

Published by Arcadia Publishing,
an imprint of Tempus Publishing, Inc.
2 Cumberland Street
Charleston, SC 29401

Printed in Great Britain.

Library of Congress Catalog Card Number: 99-69551

For all general information contact Arcadia Publishing at:
Telephone 843-853-2070
Fax 843-853-0044
E-Mail sales@arcadiapublishing.com

For customer service and orders:
Toll-Free 1-888-313-2665

Visit us on the internet at http://www.arcadiapublishing.com

Dedicated to Jack Hess and Larry Gormally,
two wonderful historians who graciously shared with me
both their knowledge and their photographs.
I received not only a deeper love of Springfield from them,
but also a generosity of spirit in sharing the city's wonderful history.

CONTENTS

ACKNOWLEDGMENTS

I would like once again, as I did in *Springfield: Volume I*, to thank the numerous people who generously gave of their time, their knowledge, and their photographs. It is deeply appreciated.

I would also like to thank my editor, Amy Sutton, for talking me through some difficult moments with this book. And, as always, thank you, Chuck, my husband, and Adam, Jess, and Seth, my children, for putting up with me while I completed this project. I could not have done it without you.

I would also like to acknowledge the following people who assisted with information and pictures: Dawn Armstrong, Claire Ashe, Ralph Bacon, Arthur Bicknell, Dr. Candy Budd-Jackson, Tony Catalfomo, Athan "Saco" Catjakis, Steve Clay, Ed Cohen, Peter Cooney, Terry Cosgriff, Rico Daniele, Neil Doherty, John Donnellan, Mallaci Fallon, Anna Giza, Larry Gormally, James P. Gurzenski, Tom Hastings, Sheila Herchuck, Jack Hess, Dr. John Howell, Roy Jinks, Mrs. Arthur Johnson, Jennifer Kasparian, Michael Korzeniowski, Lynn Larabee, Kurt Morrison, Red Murphy, Hope Murray, Mary O'Connell, Keith O'Connor, Tom O'Connor, Jack O'Donnell, Sylvia Paquette, Joe Perla, Peter Picknelly, Carolina Salvetti, Karen Scully, Walter "Tux" Sullivan, Maura Tobias, Victor Tondera, Kimberly Walsh, Bernadette White, and Virginia Zabecki.

INTRODUCTION

The city of Springfield grew, as most cities did, from the hard work and determination of its citizens. In this second volume of the city's history, I have attempted to continue the story of the people's progress and success in continually growing and adapting to changing times. Because of its people, both past and present, this great city stands as an example of what can be accomplished despite many difficult obstacles.

One

MOVING FORCES:
TRANSPORTATION
IN THE CITY

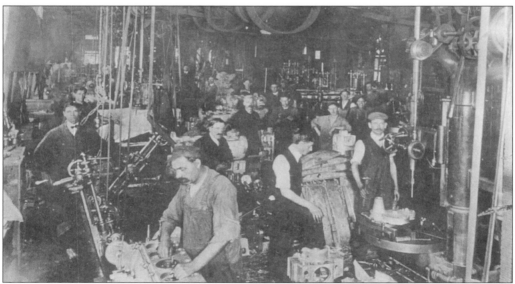

One of the most famous manufacturers in the city was the Knox Automobile Company. It was founded in 1899 by Harry A. Knox and Elisha Cutler, who was then president of the Elektron Company. Production began in the Elektron Building and was later moved to the Van Norman Building on Waltham Avenue. This 1912 picture shows men at work in the Knox machine shop. Ernest Granse stands at the far left. The Knox Automobile Company remained in business until 1927. (Courtesy of Jack Hess of the Duryea Transportation Society.)

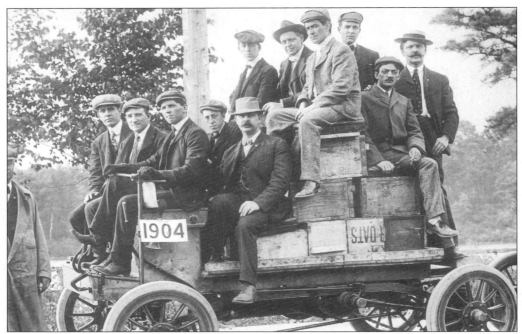

Shown is a 1904 truck being tested with a given weight load. Harry A. Knox is partially visible at the far left. Elmer Peddington is driving. Herman Farr, a Knox Company engineer, is at the top center on the right. Behind the driver is James Jones, another engineer for the company. (Courtesy of Jack Hess of the Duryea Transportation Society.)

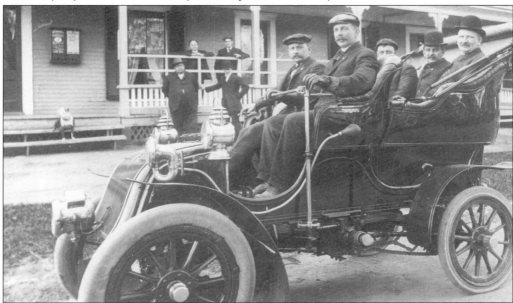

This five-passenger vehicle from 1904 had a two-cylinder engine and could travel at 35 mph. The front opened up for storage. Notice the lever steering, which lifted up when you got into the driver's seat. The tires were made with air tubes, rather than solid rubber. (Courtesy of Jack Hess of the Duryea Transportation Society.)

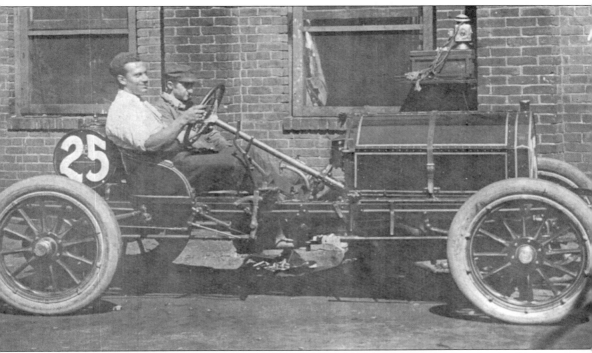

This 1909 photograph shows a Knox race car outside of the Knox plant. At the wheel is Fred Belcher, with Bill Jahn beside him. Together, they raced this car in the 1911 Indianapolis 500. (Courtesy of Jack Hess of the Duryea Transportation Society.)

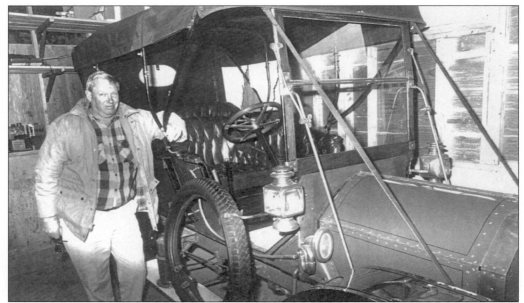

Jack Hess, author of an excellent history of Knox fire apparatus, poses with his 1907 Knox touring car. The cars produced that year by the company were the last ones to have air-cooled engines. After that, the engines were water cooled. (Courtesy of Jack Hess of the Duryea Transportation Society.)

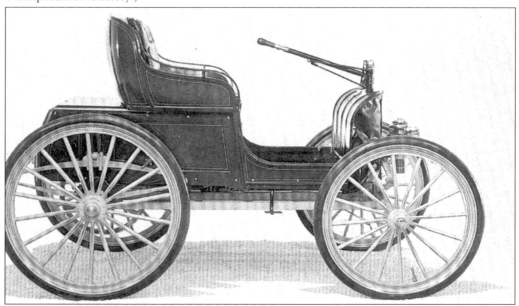

J. Frank and Charles E. Duryea invented and developed one of America's first gasoline engine cars in 1893. One of their models, built in Springfield, won America's first auto race in Chicago on Thanksgiving Day of 1895. The brothers later contracted with the A.E. Stephens Company of New York to build a modern automobile plant on 40 acres in East Springfield. The company stopped production in 1915, and Westinghouse took over the plant, producing rifles for the Russian army during World War I. (Courtesy of Jack Hess of the Duryea Transportation Society.)

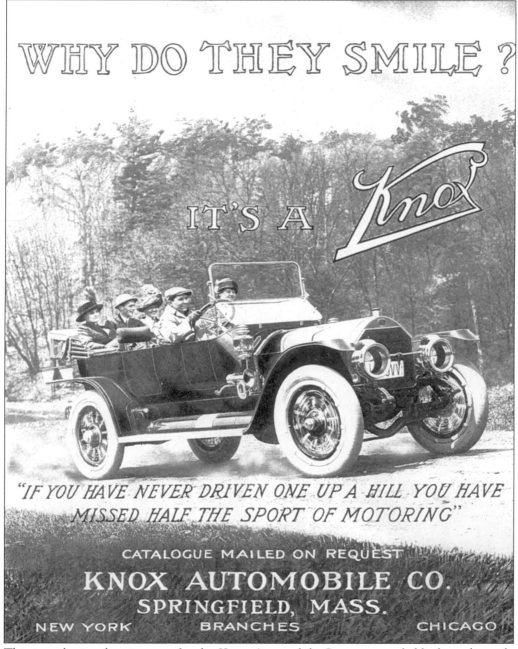

This is a classic advertisement for the Knox Automobile Company, probably from the early 1920s. James Manning, shown driving the vehicle, was the longest working employee of the company. It is interesting to note that in this model the steering wheel is on the right side. (Courtesy of Jack Hess of the Duryea Transportation Society.)

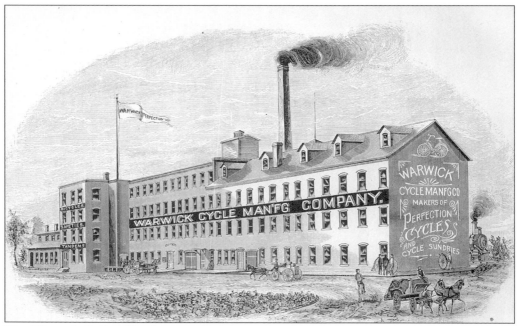

The Warwick Cycle Manufacturing Company opened in 1888 on Hanover Street in the south end of the city. The company became one of the nation's leading producers of safety bicycles. The two-wheeled models were considered safe in comparison to the high-wheeled cycles that people had used until then. (Courtesy of Jack Hess of the Duryea Transportation Society.)

PERFECTION CYCLES,———

BUILT ON HONOR.

DURABLE,—*—SWIFT,—*—HANDSOME.

Highest Grade. *Absolutely Interchangeable.*

Large Cushion Tires, Fully Guaranteed.

There seem to be two ways of advertising. ONE IS TO RUN DOWN A COMPETITOR'S GOODS, and on that alone sell what the advertiser knows to be an inferior article. ANOTHER WAY IS TO STATE PLAINLY AND BRIEFLY WHAT YOU HAVE TO SELL, and then expend all time, energy and skill in producing if possible an article that is a little better than you claim it to be.

We have watched men try the *first method*, and you know the results as well as we do. The *second method* we adopted at beginning of business, and know it to be the only way to build up a sound, substantial and ever increasing trade.

CLOSE INSPECTION OF OUR GOODS INVITED.

The Warwick Cycle Manufacturing Company grew and moved to a new facility on Warwick Street. This advertisement demonstrates the quality of the product and the honorable approach the company took in promoting its goods. (Courtesy of Jack Hess of the Duryea Transportation Society.)

14

The Warwick Cycle Manufacturing Company also produced automobiles for a few years, from 1900 to *c.* 1904. Another one of the company's advertisements heralds all the details of the quality, the features and the price of one of its bicycles, above, and one of their unique automobiles, below. (Courtesy of Jack Hess of the Duryea Transportation Society.)

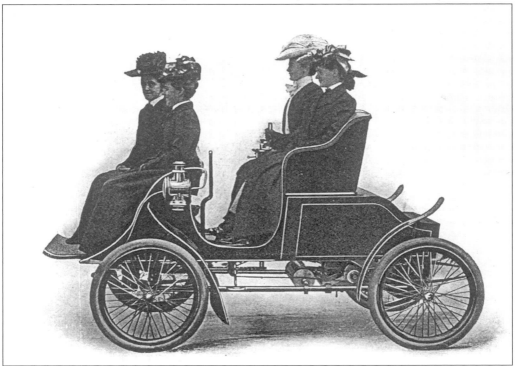

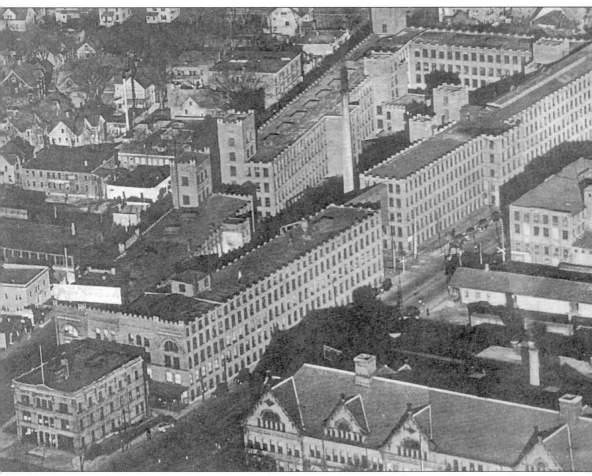

George M. Hendee, already a famous bicyclist in Springfield, became Amateur Champion Bicyclist of America in 1882 at age 15, racing on the high-wheeled bike. He started to manufacture motorcycles in Springfield in the early 20th century. The Hendee Manufacturing Company was renamed the Indian Motocycle Company in 1923. This is a view of the plant in Winchester Square, now called Mason Square. In the right foreground is the Buckingham Junior High School and just above it, the Buckingham Railroad station and the Knox plant. (Courtesy of Jack Hess of the Duryea Transportation Society.)

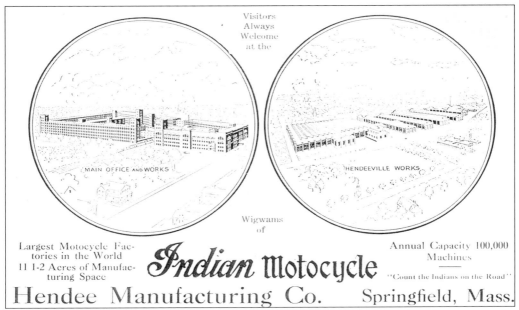

This early advertisement of the company described the Hendee Manufacturing Company as the largest motorcycle plant in the world. The plant closed in 1953, after supplying motorcycles for the state police departments of 38 states and for the police departments of more than 2,000 towns and cities across the country. (Courtesy of Jack Hess of the Duryea Transportation Society.)

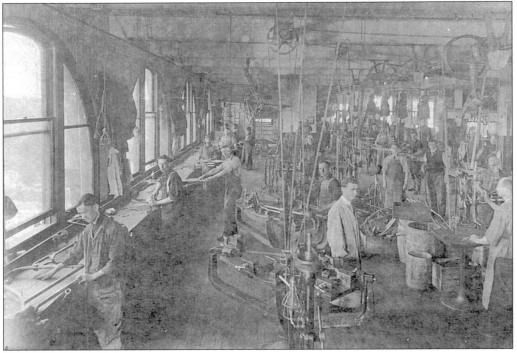

This photograph of production inside the Indian Motocycle plant shows the latest in technology at that time. (Courtesy of Jack Hess of the Duryea Transportation Society.)

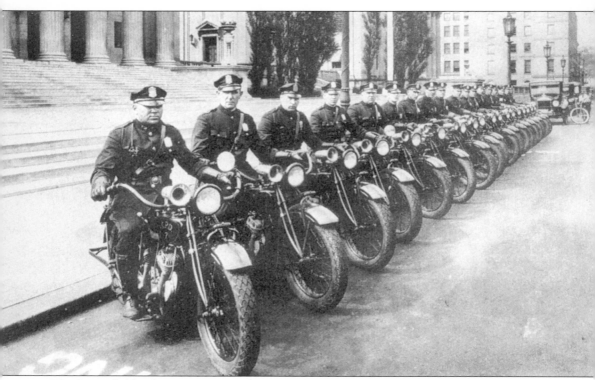

The Springfield Police Department's motorcycle squad poses in front of the city hall in 1931 on their new Indian Motocycles. Fourth from the left is police chief Ray Gallagher. (Courtesy of Jack Hess of the Duryea Transportation Society.)

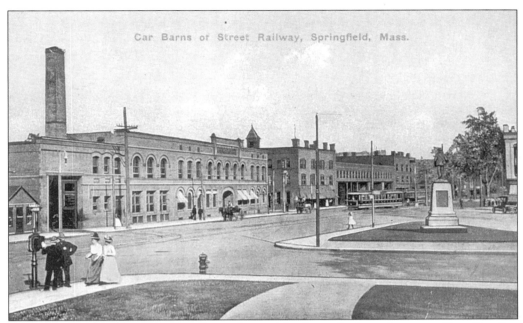

This is a vintage view of the old trolley carbarn of the Street Railway Company. Peter Pan Bus Company owns the trolley barn today. It is situated on the north end of Main Street. (Courtesy of Victor Tondera.)

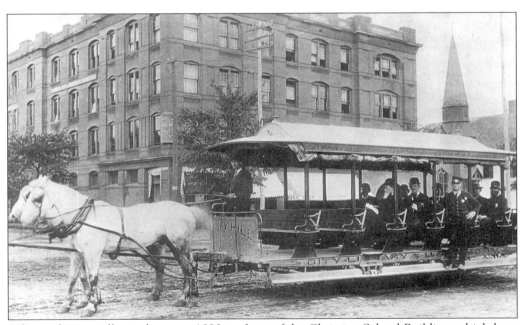

A horse-drawn trolley is shown, *c.* 1890, in front of the Christian School Building, which later became Springfield College, on the corner of State and Sherman Streets. Notice that there is a police officer sitting in the back of the trolley. (Courtesy of Jack Hess of the Duryea Transportation Society.)

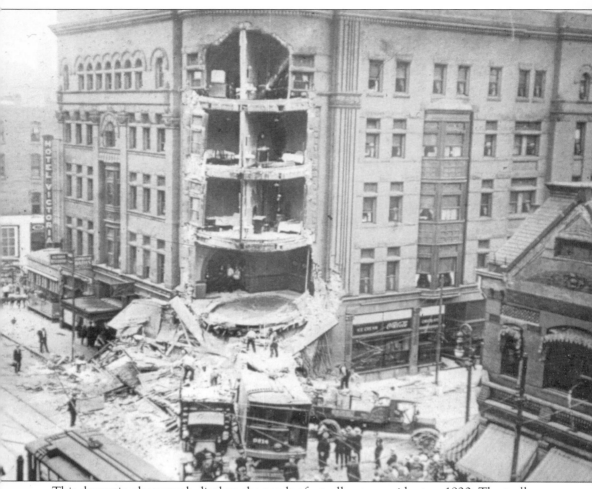

This dramatic photograph displays the result of a trolley car accident, c. 1920. The trolley car, driven by James J. Irwin, apparently jumped the track when coming down the State Street hill and crashed into the Victoria Hotel, which originally housed the YMCA. Remarkably, there were no fatalities. (Courtesy of Jack Hess of the Duryea Transportation Society.)

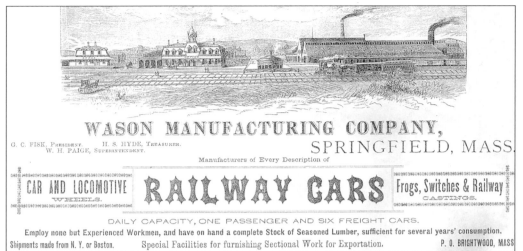

WASON MANUFACTURING COMPANY,

G. C. FISK, President. H. S. HYDE, Treasurer.
W. H. PAIGE, Superintendent.

SPRINGFIELD, MASS.

Manufacturers of Every Description of

CAR AND LOCOMOTIVE WHEELS. | **RAILWAY CARS** | **Frogs, Switches & Railway** CASTINGS.

DAILY CAPACITY, ONE PASSENGER AND SIX FREIGHT CARS.

Employ none but Experienced Workmen, and have on hand a complete Stock of Seasoned Lumber, sufficient for several years' consumption.

Shipments made from N. Y. or Boston. Special Facilities for furnishing Sectional Work for Exportation. P. O. BRIGHTWOOD, MASS.

The Wason Car Manufacturing Company began in Springfield in 1845. Owned by Thomas and Charles Wason, the company moved to Brightwood in 1870. It became the largest manufacturer in New England, employing more than 700 people. The company produced railroad and trolley cars, which it supplied to a worldwide market. (Courtesy of Jack Hess of the Duryea Transportation Society.)

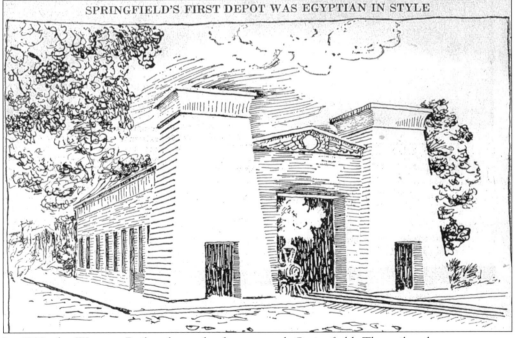

SPRINGFIELD'S FIRST DEPOT WAS EGYPTIAN IN STYLE

In 1839, the Western Railroad was the first to reach Springfield. The railroad ran an eastern line from Boston to Springfield, followed by a later expansion to Albany in 1841. Later in the 1840s, a north–south line linked Springfield to Vermont. This sketch demonstrates what the first depot in the city looked like. Opened in 1839, it was a wood structure with a unique Egyptian design. Sparks from a wood-burning stove caused a fire which destroyed the depot in 1851. (Courtesy of Jack Hess of the Duryea Transportation Society.)

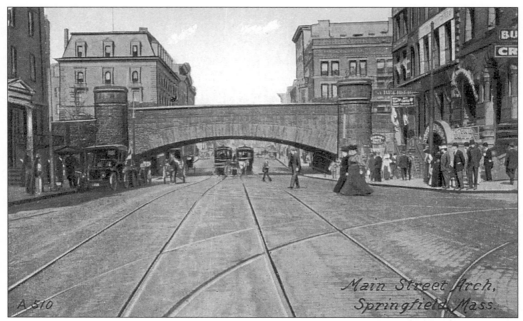

The railroad arch was built in 1890 so that the trains could cross Main Street above street level rather than on the road itself, which had proven to be a very dangerous practice. (Courtesy of Victor Tondera.)

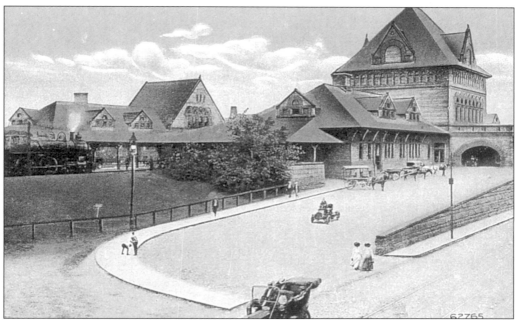

Springfield's third train depot, the Union Station, opened on the east side of Main Street in 1889. Built of granite and sandstone, it was demolished in 1920 to make way for the new station, which remains to this day. (Courtesy of Victor Tondera.)

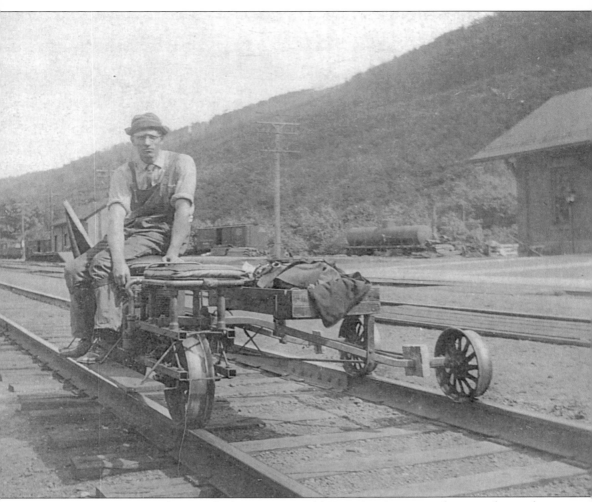

This early-20th-century photograph shows 19-year-old Harry M. Sturgis working on the road gang of the Boston & Albany Railroad. He went on to become the wire chief for the railroad company, where he worked his entire life. (Courtesy of his grandson Jack Hess of the Duryea Transportation Society.)

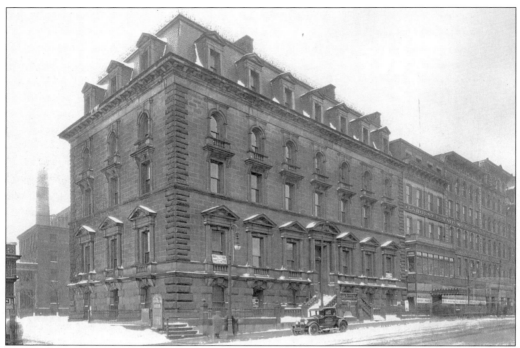

The Boston & Albany Railroad office building, located on Main Street west of the railroad arch, was also called the Granite Building. The building was designed by H.H. Richardson and was torn down in 1930. (Courtesy of Jack Hess of the Duryea Transportation Society.)

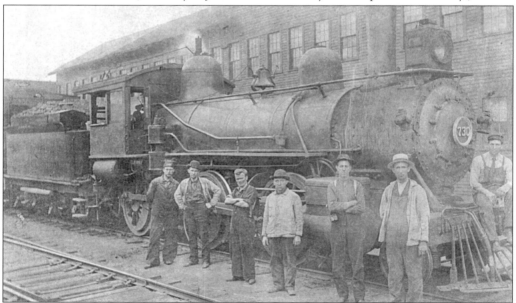

Railroad employees pose in 1895 with an engine from the Highland line of the New York, New Hampshire & Hartford Railroad Company. The Knox plant is in the background. This line carried many Knox and Hendee products to their final destinations. (Courtesy of Jack Hess of the Duryea Transportation Society.)

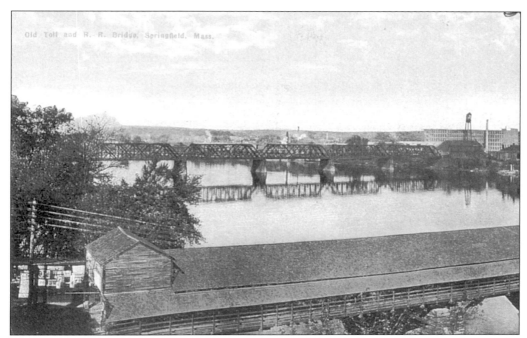

The first bridge over the Connecticut River in Springfield was built in 1805. Washed out in the spring nine years later, it was replaced by a new toll bridge in 1816. Tolls were collected on this covered bridge until 1872. (Courtesy of Victor Tondera.)

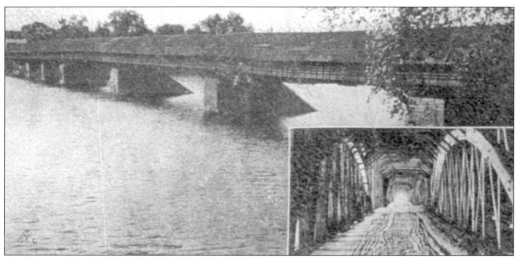

Another view of the toll bridge from a different angle shows that this second bridge was built to stay. The heavy pine timbers of the arches, seen in the interior view, were floated down the river from the White Mountains and were hewn by hand. Pres. James Monroe passed over this bridge in 1817 when making his famous New England tour. (Courtesy of Victor Tondera.)

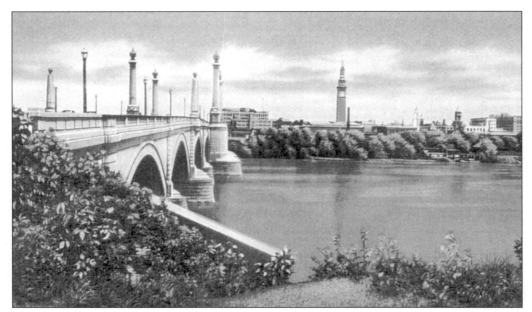

The Hampden County Memorial Bridge over the Connecticut River was built near the center of the city in 1922. This view from the West Springfield side of the river shows the city skyline, probably in the late 1920s. (Courtesy of Victor Tondera.)

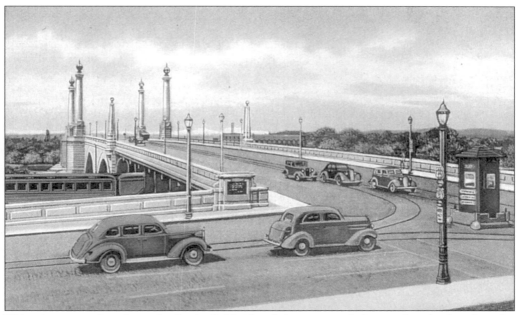

This view was taken from the Springfield side of the river and shows a booth placed in the middle of the lanes. A train going under the bridge is also visible. Tracks ran alongside the river, as they still do today. (Courtesy of Victor Tondera.)

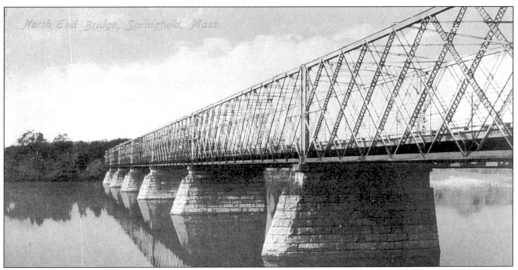

The first North End bridge over the river was built in 1876. This photograph shows the original bridge, which was destroyed by fire in 1923. The bridge was replaced by the new and current bridge, which opened on July 1, 1925. (Courtesy of Victor Tondera.)

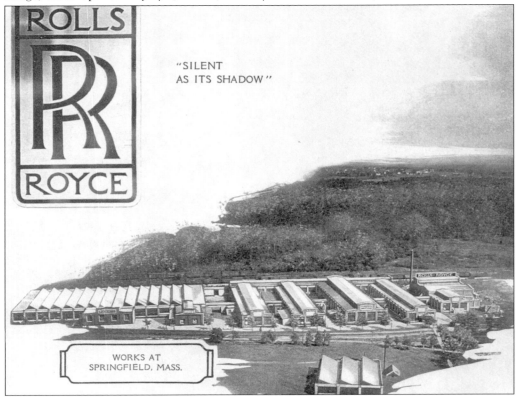

From 1920 to 1930, the Rolls Royce Company rented the East Springfield plant of the Indian Motocycle Company to produce automobiles. Some of Rolls Royce's most famous cars were made here in Springfield. (Courtesy of Jack Hess of the Duryea Transportation Society.)

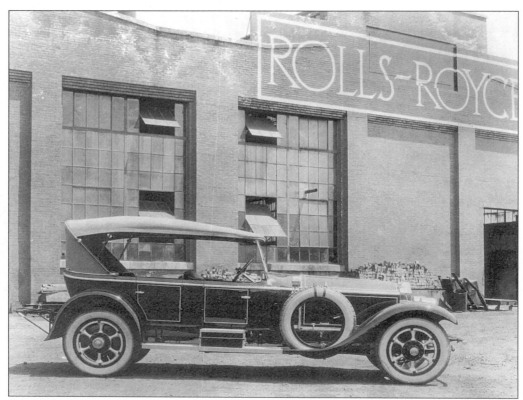

A completed new Rolls Royce is displayed in front of the plant off Hendee Street in the 1920s. (Courtesy of Jack Hess of the Duryea Transportation Society.)

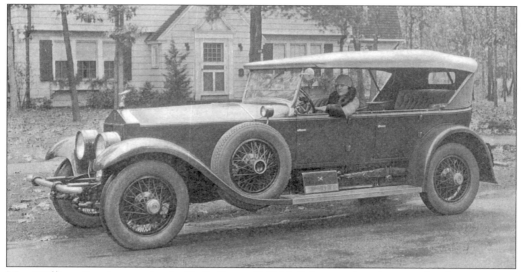

Mrs. William Bemis poses in the Rolls Royce Pall-Mall for an advertisement for the company. She was a member of the family who ran the Bemis & Call Hardware and Tool Company. (Courtesy of Jack Hess of the Duryea Transportation Society.)

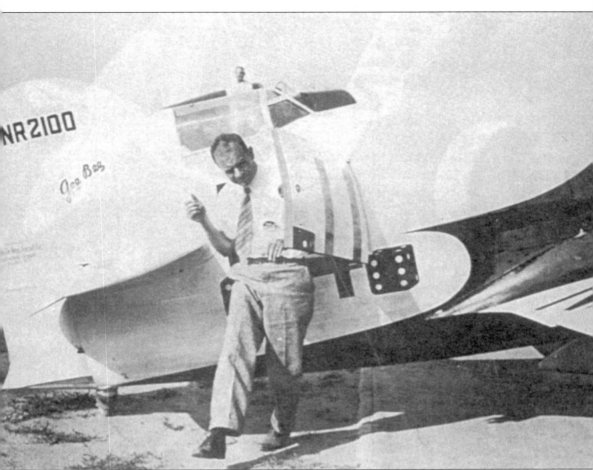

In the 1920s, the five Granville brothers—Robert, Zantford, Thomas, Edward, and Mark—began the Granville Brothers Aircraft Corporation. The company made biplanes and monoplanes at the old Springfield Airport (now the Springfield Plaza). This picture shows famed aviator Jimmy Doolittle emerging from a Gee-Bee R 1 monoplane at the Cleveland air races. In 1932, Doolittle flew to a world record land plane speed in a Gee-Bee. (Courtesy of Jack Hess of the Duryea Transportation Society.)

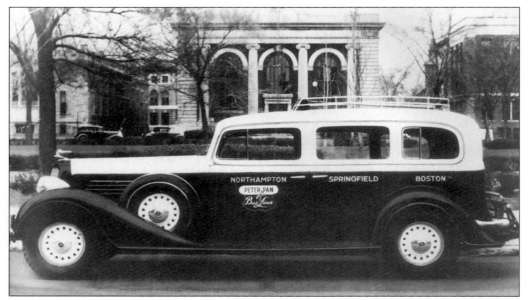

Peter Carmine Picknelly founded the Peter Pan Bus Lines in 1933, when he purchased the assets of the Yellow Cab Air Line in Springfield. He then bought two seven-passenger vehicles and the right to transport people along a route connecting Northampton, Springfield, Worcester, and Boston. This 1934 Buick Jitney was photographed at Court Square from the steps of Symphony Hall. (Courtesy of Peter L. Picknelly.)

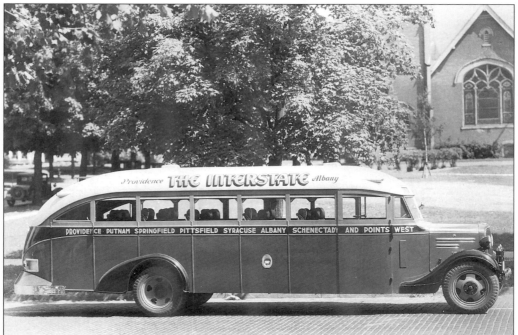

Peter C. Picknelly was president and co-owner of the Interstate Buses Corporation before his formation of the Peter Pan Bus Lines. This is a 1930s interstate coach, Chevrolet model 19-c-76. (Courtesy of Peter L. Picknelly.)

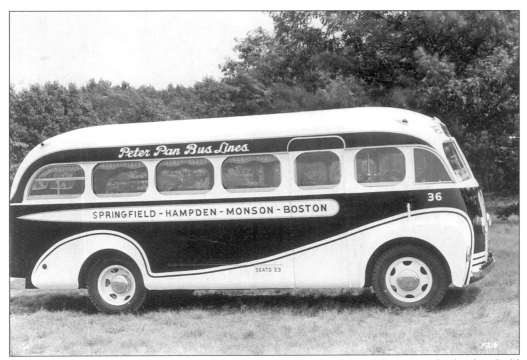

Bus styles changed over the years. Bus No. 36 was a 1941 FitzJohn Falcon Jr., which often held as many as 50 passengers on the commuter run through Hampden and Monson. This style bus came complete with curtains. (Courtesy of Peter L. Picknelly.)

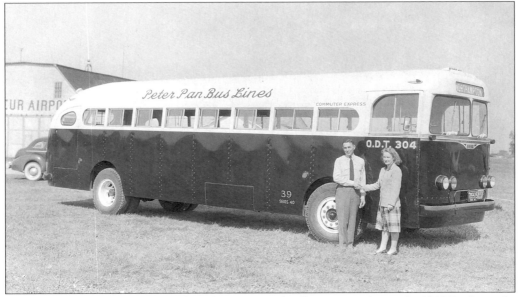

William Carmine Picknelly, brother of Peter L. Picknelly, poses in front of a 1942 Beck coach. He joined the company in 1942. Today, the company is still owned and operated by the children and grandchildren of Peter C. Picknelly and is the largest privately owned intercity bus line in the United States. (Courtesy of Peter L. Picknelly.)

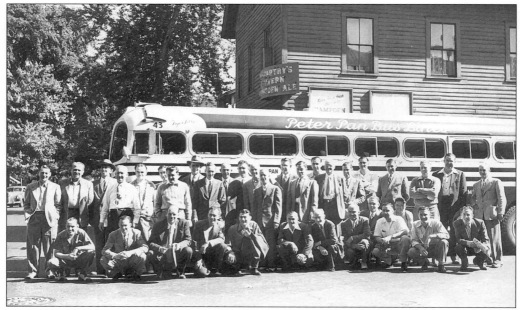

Peter Pan Bus Lines was an early leader in bus tours and charters. It was one of the first companies to receive authorization for packaged trips to baseball games at Fenway Park in Boston. The company later added charter trips to flower shows and ski resorts. This 1953 photograph shows a group of men leaving from McCarthy's Tavern on an organized trip to Boston. (Courtesy of Peter L. Picknelly.)

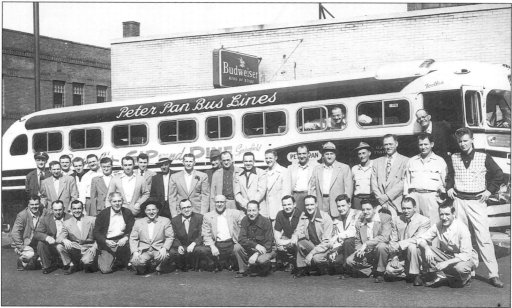

Another 1953 tour is shown leaving from another Springfield tavern. These sports game trips often went to Fenway Park but were also planned for games at Braves Field or for trips to Suffolk Downs Racetrack, both also in Boston. In 1945, Peter Pan Bus Lines received authority for a charter route to the Rockingham Racetrack in New Hampshire. (Courtesy of Peter L. Picknelly.)

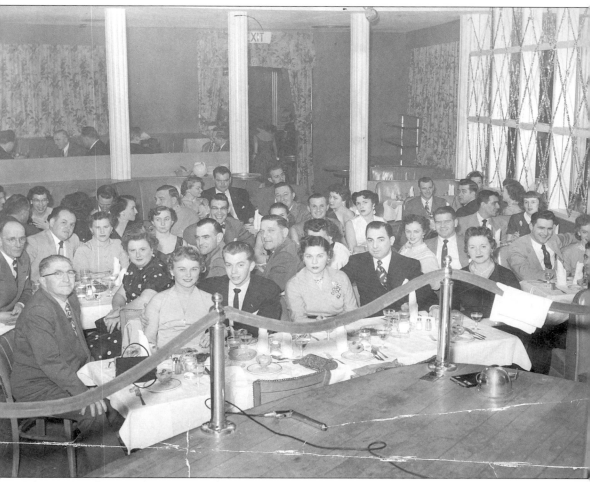

This 1950s photograph shows a Peter Pan Bus Lines company Christmas party. In the front, from left to right, are Peter C. Picknelly, Mary Picknelly, Peter L. Picknelly, Mr. & Mrs. Joseph Maddaloni, and Jennie Picknelly. Today, the bus line provides daily service to some 100 cities throughout the Northeast, with a fleet of 150 motor coaches, and employs more than 800 workers. (Courtesy of Peter L. Picknelly.)

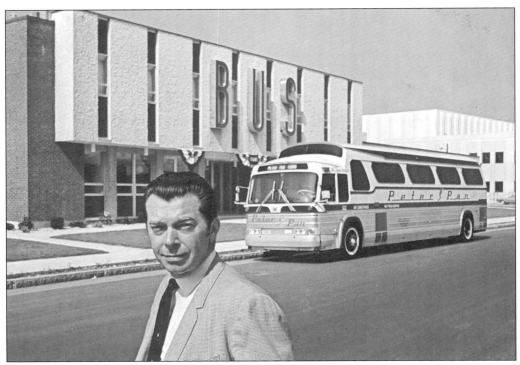

Ground was broken in September 1968 for a new bus terminal. On April 1,1969, the Springfield Bus Terminal Inc. opened on Main Street and for the first time in 14 years, all of Springfield's bus carriers were in one location. Above, Peter L. Picknelly, then president of Peter Pan Bus Lines and now chairman, stands in front of the building in 1971. (Courtesy of Peter L. Picknelly.)

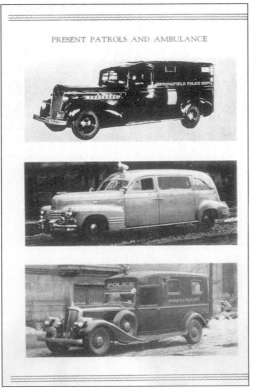

PRESENT PATROLS AND AMBULANCE

This view shows what city vehicles looked like earlier in the 20th century. Modern at the time, probably the 1930s, they provided the best in safety vehicles for the people of Springfield. (Courtesy of Jack Hess of the Duryea Transportation Society.)

Two
THE BUILDING BLOCKS OF ECONOMY

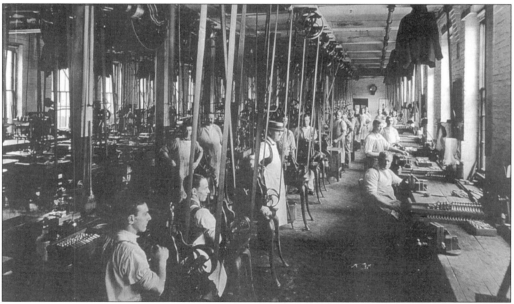

The Smith & Wesson Company was formed by Horace Smith, who learned his trade at the U.S. Armory in Springfield, and by Daniel B. Wesson, who was taught the craft by his brother Edwin Wesson. In 1852, after meeting at Robbins and Lawrence Company of Windsor, Vermont, the two men formed their first partnership in Norwich, Connecticut, to manufacture a lever-action pistol that incorporated a tubular magazine and that fired a fully self-contained cartridge. This picture, likely from 1890 or the early 1900s, shows men at work in the frame department. (Courtesy of the Roy G. Jinks Collections.)

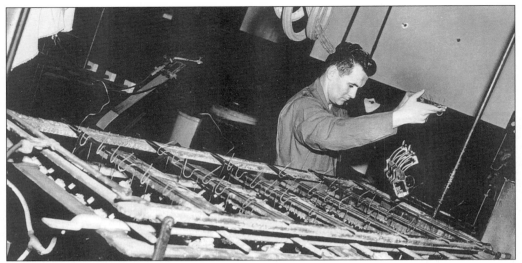

The first Smith & Wesson gun produced was nicknamed "the volcanic" by *Scientific American* because its rapid-fire sequence appeared to have the force of an erupting volcano. In 1854, financial difficulties caused a reorganization with a new investor, Oliver Winchester, and the factory moved to New Haven, Connecticut. In 1866, the organization became the Winchester Repeating Arms Company. Shown is an employee in the frame department in the 1950s. (Courtesy of the Roy G. Jinks Collections.)

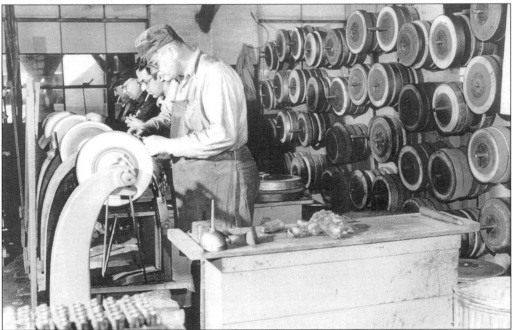

Smith & Wesson later agreed to re-form their partnership to produce revolvers in a small shop on Market Street in Springfield. The company had successfully negotiated a license agreement with Rollin White for his patent of a cylinder. The new revolver was called the Model 1. This c. 1950 view shows employees in the polishing department of the Springfield plant. (Courtesy of the Roy G. Jinks Collections.)

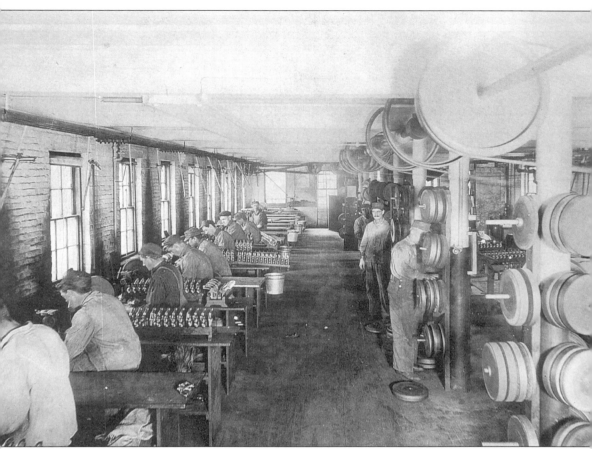

In 1859, Smith & Wesson built a new factory on Stockbridge Street in Springfield, and the company continued to grow. Demand increased during the Civil War, which helped to establish Smith & Wesson as a leading firearms manufacturer. In 1867, the company decided to expand to the European market, and Henry W. Hallett organized a display of the arms at the gun exposition in Paris. This photograph shows men at work in the polishing department in the early years. (Courtesy of the Roy G. Jinks Collections.)

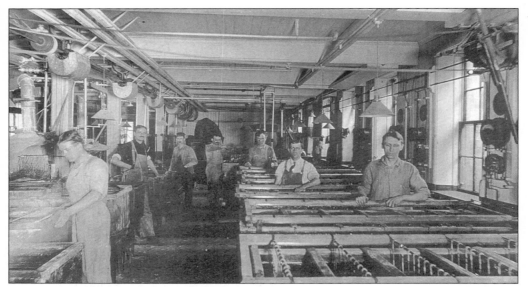

At the gun exposition in Paris, the Russian Grand Duke Alexis purchased several pistols for himself. This new market helped Smith & Wesson survive the effects of a postwar depression. In May 1871, the Russian government ordered 20,000 Model 3 revolvers, paying the company with gold. Shown here are workers in the plating department at the beginning of the 20th century. (Courtesy of the Roy G. Jinks Collections.)

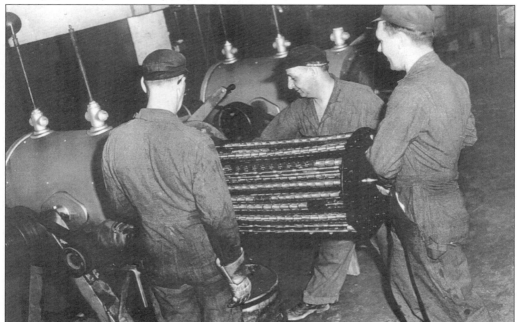

In 1880, Smith & Wesson expanded its line with double-action revolvers. In 1889, the company produced one of its most famous revolvers, the .38 Military and Police. During the 1930s, the company introduced the K-22 Outdoorsman and the .357 Magnum. In December 1949, the company moved to its new and current plant on Roosevelt Avenue. This photograph shows men working on the bluing process at the new plant. (Courtesy of the Roy G. Jinks Collections.)

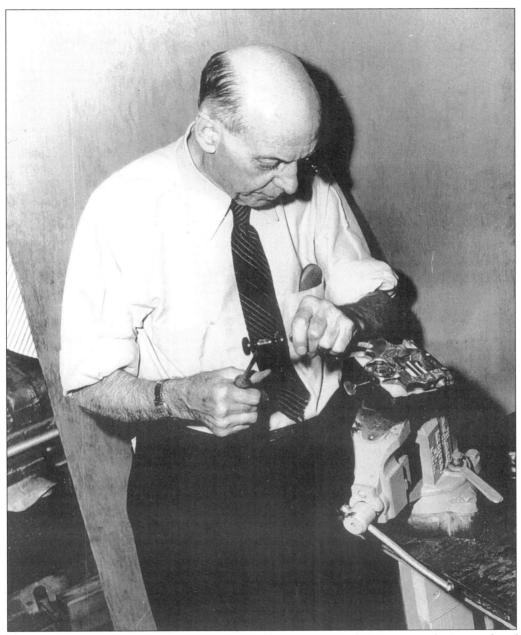

Smith & Wesson often added exquisite engraving to the crafted firearms, producing works of art. Some famous early engravers included Richard Bates Inshaw, Gustave Young, Oscar Young, and Eugene Young. Harry Jarvis, shown here in the 1950s, was a notable engraver of the company. (Courtesy of the Roy G. Jinks Collections.)

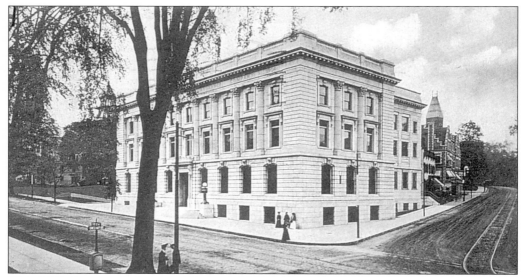

This 1907 photograph shows the Springfield Fire and Marine Insurance Company, one of the early insurance companies in the city. The company was located at the corner of Maple and State Streets, in the building now occupied by the city's school department. (Courtesy of Victor Tondera.)

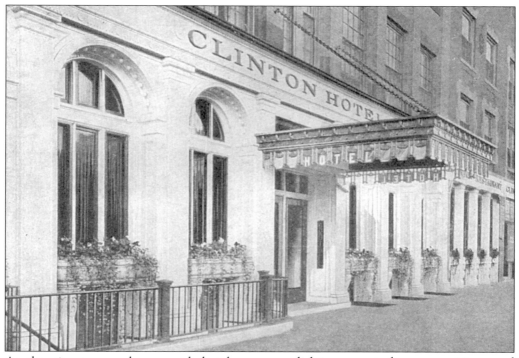

As the city grew and prospered, hotels were needed to support the many visitors and businesspeople who came to the city. The Massosoit House was the pride of the 19th century. In the 20th century, new establishments, such as the Clinton Hotel, shown above, were developed. (Courtesy of Victor Tondera.)

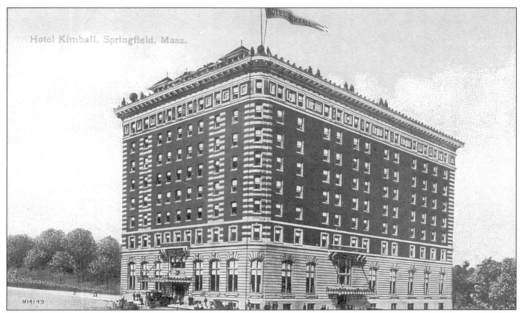

The Hotel Kimball, located on Chestnut Street, is shown here with very little else around it. For years, this hotel served the city's many distinguished guests, including Babe Ruth. (Courtesy of Victor Tondera.)

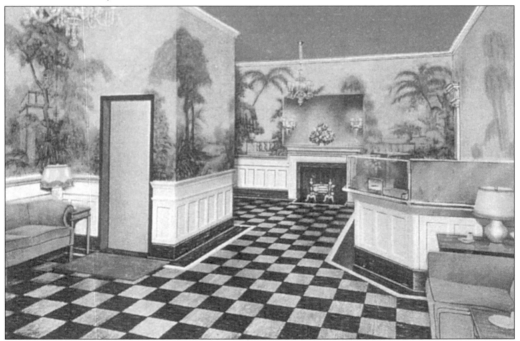

This photograph shows the entrance lobby of the Hotel Highland in the early 1900s. Rates then were listed as follows: single room with detached bath, $2.75 to $3; single room with private bath, $3.50 to $5.50; double room with detached bath, $3.50 to $6; double room with private bath, $5.50 to $9. The hotel advertised "radio muzak in every room." (Courtesy of Victor Tondera.)

This vintage photograph shows the old Phelps Publishing Company, one of many publishers located in the city at the time.

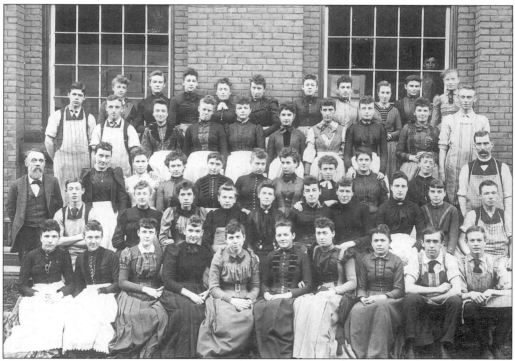

This photograph of employees at a Springfield factory was taken *c.* 1900. The exact plant cannot be identified, but it is interesting to note that many women are working and that both the men and the women are wearing aprons.

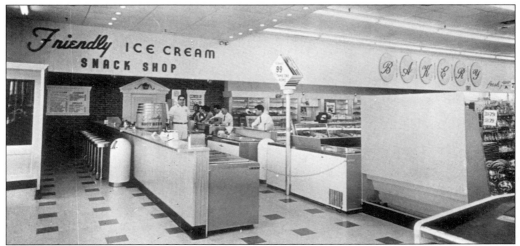

With a loan from their parents, Curtis and Prestley Blake opened a small ice-cream shop in 1935. Their business grew and in 1940, they opened a second shop in West Springfield. By 1951, Friendly's had ten stores. This view shows the interior of an early Friendly's on Boston Road. (Courtesy of Friendly Ice Cream Corporation.)

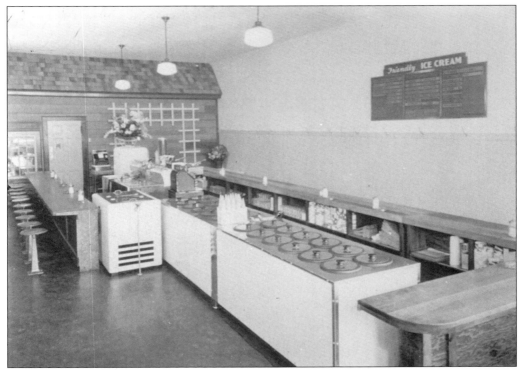

Listening to their customers' suggestions, the Blake brothers soon added hamburgers to their ice-cream store menu. As the company's rapid growth continued through the 1950s, the need for a manufacturing and distribution plant developed. In 1960, Friendly's moved to new headquarters in Wilbraham. Today, Friendly's makes more than 50 flavors of ice cream. (Courtesy of Friendly Ice Cream Corporation.)

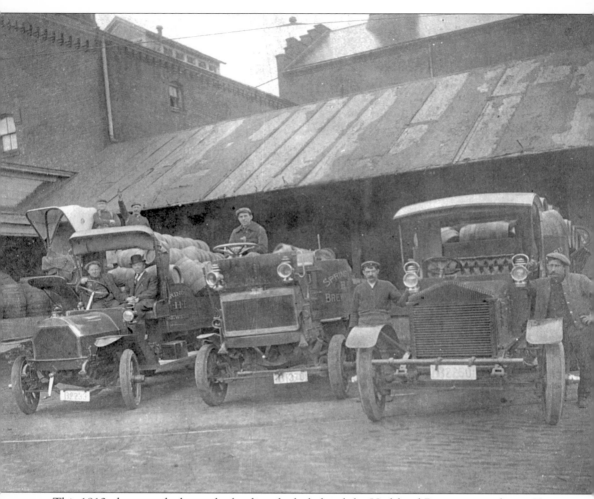

This 1912 photograph shows the loading docks behind the Highland Breweries, with two Knox trucks on the left and an unidentified truck on the right. Highland Breweries began with horse-drawn trucks and later converted to the Knox vehicles. (Courtesy of Jack Hess of the Duryea Transportation Society.)

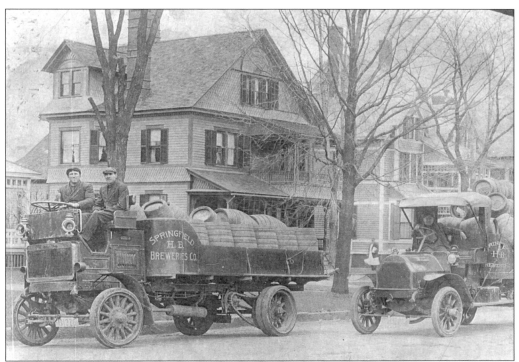

This 1910 photograph shows workers delivering from the Springfield Breweries Company Highland Branch on Knox trucks. The breweries were located on the current State Street site of the Massachusetts Mutual Insurance Company. (Courtesy of Jack Hess of the Duryea Transportation Society.)

Another brewery in the city was Kalmbach and Geisel, of which the grandfather of author Theodore Geisel (Dr. Seuss) was a partner. This 1894 flyer advertises the brewery's newest product: Bairisch beer. (Courtesy of Jack Hess of the Duryea Transportation Society.)

KALMBACH & GEISEL'S
NEW PRODUCT.
——THE——
BAIRISCH BEER
THICK MASH.

This Beer has been submitted to chemical analysis at the First Scientific Station for the Art Brewing, New York city, with the following result:

THE ANALYSIS.

ALCOHOL,	4.51
EXTRACT,	5.97
SUGAR,	2.14
DEXTRINE,	1.82
ORIGINAL EXTRACT,	14.7
REAL FERMENTATION,	59.3

The analyzing chemist also characterizes this beer as being particularly free from unsugared starch and that the deg of fermentation is nearly perfect, making it very valuable as a food beer.

IT IS UNSURPASSED.

IT IS EQUAL TO THE FAMOUS WURZBURGER OR MUENCHNER.

BREWED ONLY BY

KALMBACH & GEISEL,
SPRINGFIELD, MASS.

Also brewers of Export and Libotschaner Lager Beer, Stock Ale and Porte

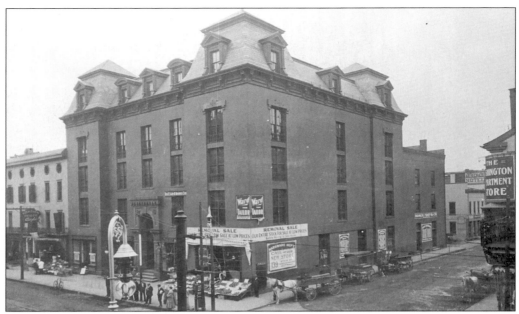

On May 15, 1851, the Massachusetts Mutual Life Insurance Company was founded when the Commonwealth of Massachusetts granted it a charter. Caleb Rice was its first president; in 1852, he was elected mayor of the city. This is the first building in which the company had an office, the Homer Foot block on the corner of Main and State Streets. The business occupied one room. (Courtesy of Massachusetts Mutual Life Insurance Company.)

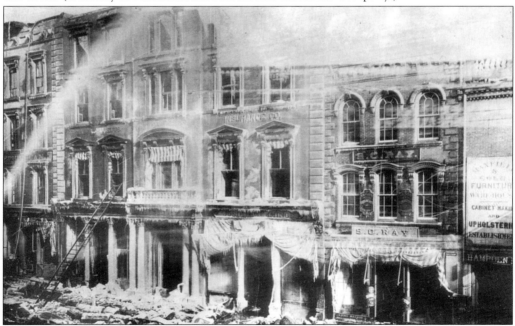

In 1868, the Massachusetts Mutual Life Insurance Company moved into its first home office building on Main Street, just north of Court Street. The building was destroyed by fire on February 5, 1873. (Courtesy of Massachusetts Mutual Life Insurance Company.)

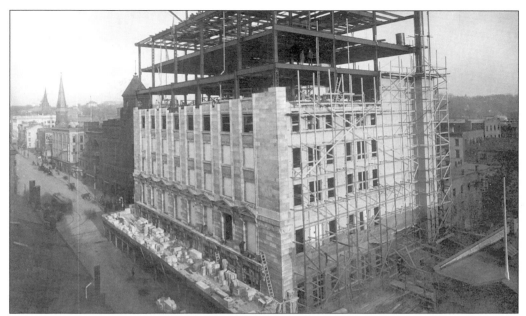

By 1908, the staff of the Massachusetts Mutual Life Insurance Company had grown to more than 100, and the company decided to build a new home office on the corner of Main and State Streets. Massachusetts Mutual occupied the new building on October 9, 1908, the day the company's assets surpassed $50 million. This view shows the new building as it nears completion. (Courtesy of Massachusetts Mutual Life Insurance Company.)

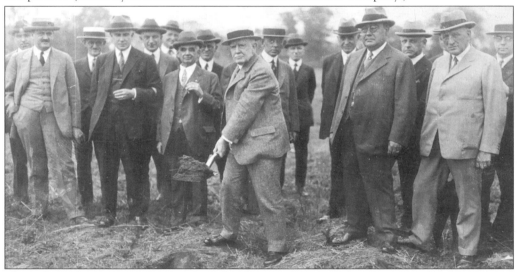

Ground was broken on June 2, 1925, for the current Massachusetts Mutual Life Insurance Company building on State Street, a site that was once owned by the Springfield Breweries. At the groundbreaking ceremony are the company officers, from left to right: (front row) A.C. Tozzer, B.J. Perry, W.H. Hall, company president W.W. McClench, W.H. Sargeant, and H.R. Bemis; (middle row) H.H. Pierce, B.H. Wulfekoetter, R. Little, A.D. Shaw, H.G. Fisk, L.W. Besse, C.C. McElwain, and C.H. Angell; (back row) L. Danziger and S.J. Johnson. (Courtesy of Massachusetts Mutual Life Insurance Company.)

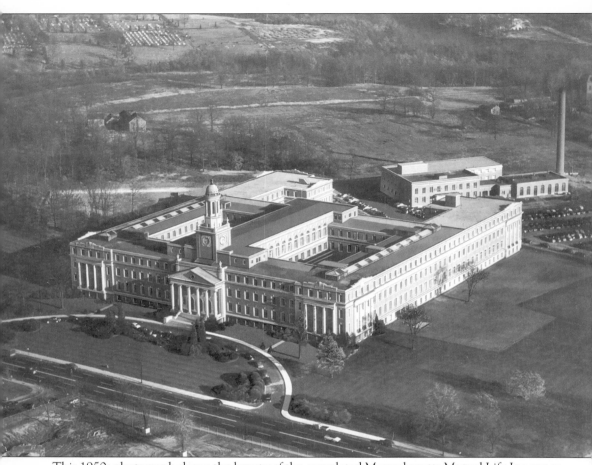

This 1950s photograph shows the beauty of the completed Massachusetts Mutual Life Insurance Company building. Additions to the original building were constructed in 1951, 1965, and 1981. Other buildings were also added to the campus over time. The building architects were Kirkham & Parleett, and the landscape architects were the Olmstead Brothers of Brookline. The current campus now has seven buildings. (Courtesy of Massachusetts Mutual Life Insurance Company.)

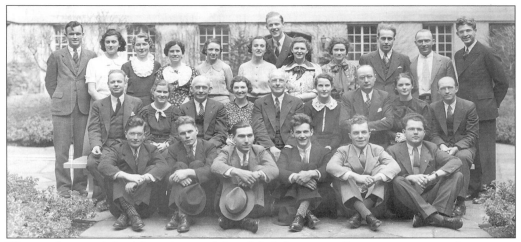

The employees of the Massachusetts Mutual Life Insurance Company mortgage department pose in this 1936 photograph. They are, from left to right, as follows: (first row) William Doppman, W. Lawrence Schenck, Emanuel Tesoro, Reginald Beauvais, Spencer Moore, and Arthur Johnson; (second row) Harry Arnold, Ruth Shaw, Leon Bartlett, Bernice Radcliffe, William Rawlings, Eva McNiven, Bert Mount, Doris Lamson, and Roy Fenton; (third row) Charles Parnell, Winifred Longwill, Emily Gimska, Gladys Cole, Christine Yule, Marie Bianchi, Virginia Birchard, Jane Fuller, Howard Lundberg, Fred Luippold, and Stuart Knox; (fourth row) Bion Wheeler. (Courtesy of Massachusetts Mutual Life Insurance Company.)

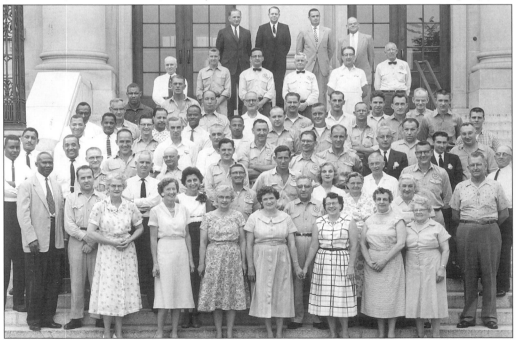

Women were a large part of the employee pool, as seen in this August 1959 photograph of the Massachusetts Mutual Life Insurance Company's maintenance and warehouse personnel. That year, the company first sold more than $1 billion in individual life insurance. By 1960, the home office staff had grown to 1,850. (Courtesy of Massachusetts Mutual Life Insurance Company.)

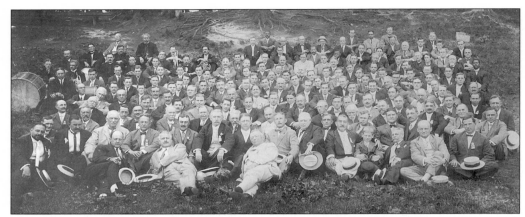

The 18th annual meeting of the Agents Association of the Massachusetts Mutual Life Insurance Company was held on August 21, 1909, at Riverside Grove. A clambake (with only men representing the company) was held. A curious custom dictated that a funeral dirge was held for the clams before the feast. Music was provided by the musicians in the upper left of the picture. (Courtesy of Massachusetts Mutual Life Insurance Company.)

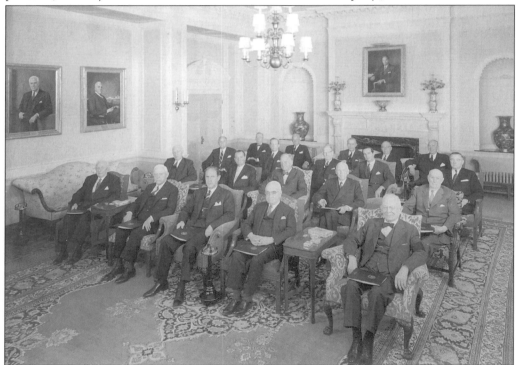

In 1959, the Massachusetts Mutual Life Insurance Company Board of Directors poses for a formal photograph. They are, from left to right, as follows: (first row) Leland J. Calmat, Gilbert H. Montague, Charles C. McElwain, E. Kent Swift, and Joseph K. Milliken; (second row) Persis D. Houston, Chester O. Fischer, Harry H. Pierce, Richard C. Guest, and Harold A. Ley; (third row) Harold J. Walter, G. Victor Sammet, Bertrand J. Perry, Joel E. Harrell, and Richard Lewis; (fourth row) Charles F. Robbins, William H. Nye, Charles P. McCormick, Andrew B. Wallace, and R. DeWitt Mallary. (Courtesy of Massachusetts Mutual Life Insurance Company.)

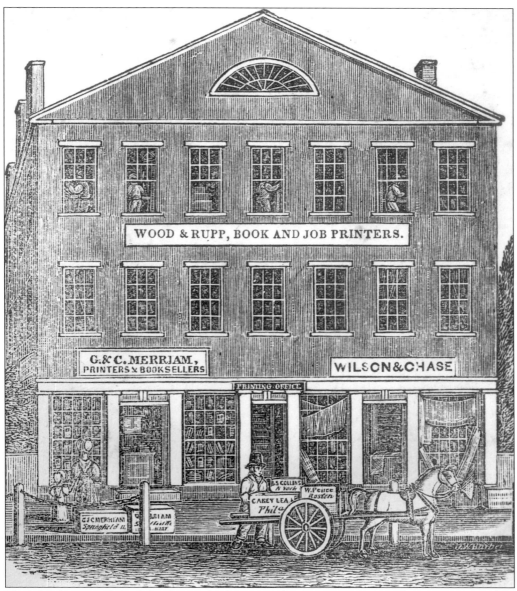

Noah Webster published the first truly American dictionary, *A Compendious Dictionary of the English Language*, and in 1828, he published *An American Dictionary of the English Language*. Meanwhile, George and Charles Merriam opened a printing and bookselling company in Springfield in 1831. They bought the unsold rights of the 1841 edition of *An American Dictionary of the English Language* from Webster's heirs and second rights to create revised editions of it. This view shows the Merriam headquarters in 1847, the year that the first Merriam-Webster dictionary was published. (Courtesy of Merriam-Webster Inc.)

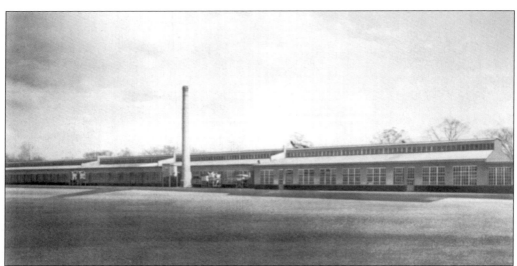

Noah Webster made these notes for his dictionary. Believing that the cultural independence of the United States should be developed, he learned 26 languages in order to research the origins of his country's own distinctive language and idioms. He was the first to document unique American words, such as *chowder*; in addition, he altered the spelling of many words, for example, changing *centre* to *center* and *musick* to *music*. (Courtesy of Merriam-Webster Inc.)

In 1900, the Moore Drop Forging Company began making bicycle frames, in 1909, wrenches, and in 1914, automotive forging and machining. In 1938, Moore started to make hand tools for the Sears Company; in 1946, it purchased the Wason Car Works plant. This photograph shows the plant that was designed, built, and equipped for the exclusive production of Craftsman open-end, box-end, combination and tappet wrenches, and the complete socket wrench line. (Courtesy of Danaher Tool Company.)

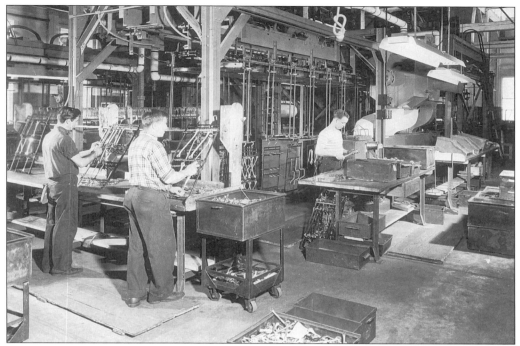

Employees of Moore Drop Forge Company in 1947 rack the wrenches for plating with copper and bright nickel and chromium. In December 1967, the Eastern Stainless Steel Company bought 95 percent of Moore Drop Forge. In 1969, the company restructured as the Easco Corporation. (Courtesy of Danaher Tool Company.)

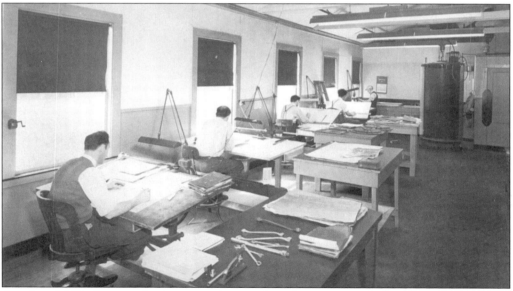

Another 1947 photograph shows product and tool engineers of the Moore Drop Forge Company. Easco was taken over by Equity group holdings in 1985 and became public in 1987. It merged with Danaher Tool in June 1990. Today, the company continues to produce fine quality tools. (Courtesy of Danaher Tool Company.)

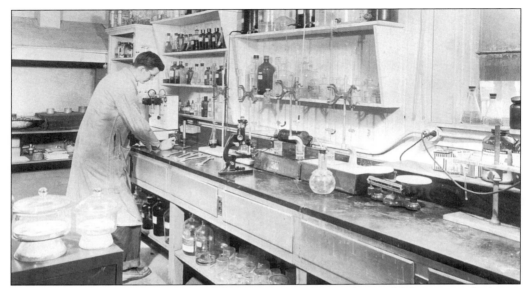

This 1947 view shows the interior of the Moore Drop Forge chemical laboratory, which was designed to maintain the constant quality of all the finish on the tools. By 1950, Moore had more than 1,500 employees. (Courtesy of Danaher Tool Company.)

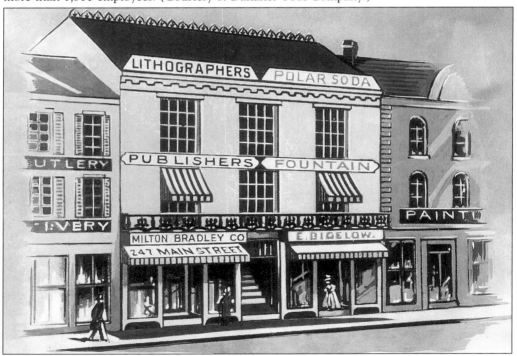

Born in Vienna, Maine, in 1836, Milton Bradley moved to Springfield in 1856 to work as a draftsman. He began his own business in 1858. In 1860, he started the Milton Bradley Company as a publisher and lithographer. This sketch shows the company's first office, at 247 Main Street. (Courtesy of Milton Bradley Co. Milton Bradley is a division of Hasbro, Inc. Copyright 2000 Hasbro, Inc. All rights reserved. Used with permission.)

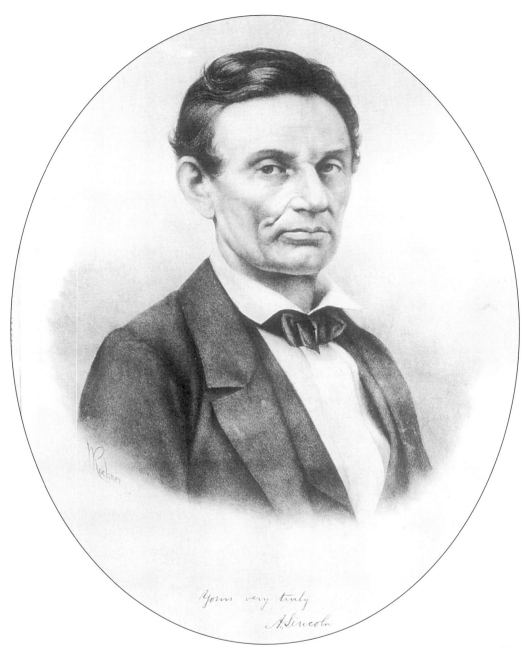

In 1860, Milton Bradley produced a lithograph of a young Abraham Lincoln, just nominated for president of the United States. The lithograph was a success but quickly became obsolete once Lincoln grew his famous beard. (Courtesy of Milton Bradley Co. Milton Bradley is a division of Hasbro, Inc. Copyright 2000 Hasbro, Inc. All rights reserved. Used with permission.)

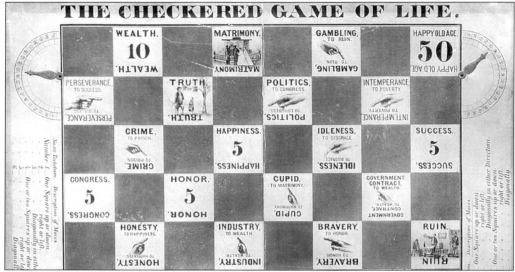

Milton Bradley designed and produced his first game, the Checkered Game of Life, in 1860. The game was sold to some shops in New York City and by 1861, the company had sold more than 40,000 copies of the game. Bradley soon focused on games. (Courtesy of Milton Bradley Co. Milton Bradley is a division of Hasbro, Inc. Copyright 2000 Hasbro, Inc. All rights reserved. Used with permission.)

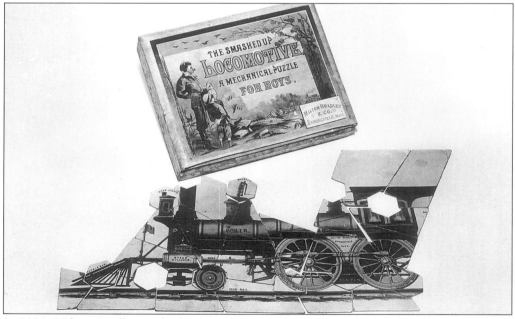

In 1880, Milton Bradley made the first jigsaw puzzle for children, the Smashed Locomotive. The puzzle was followed by his invention and patent of the one-armed paper cutter, still seen in schools and offices today. The company moved to East Longmeadow in 1962 and today, it is the number one maker of games and puzzles in the world. (Courtesy of Milton Bradley Co. Milton Bradley is a division of Hasbro, Inc. Copyright 2000 Hasbro, Inc. All rights reserved. Used with permission.)

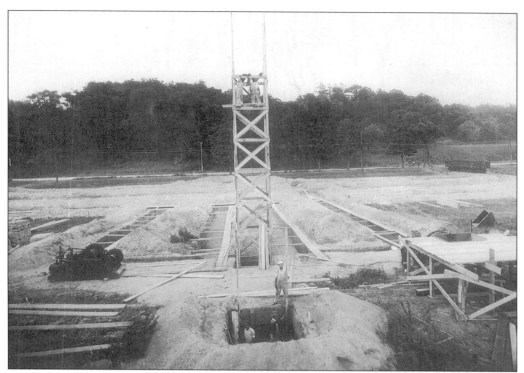

Robert Bosch, a citizen of Stuttgart, Germany, developed a magneto ignition to work off the chain-driven crankshaft of gasoline engines. He began production of the magnetos in Germany. In 1910, he built his first factory in the United States in Springfield; this photograph shows the very first step in the construction of that plant. (Courtesy of Jack O'Donnell.)

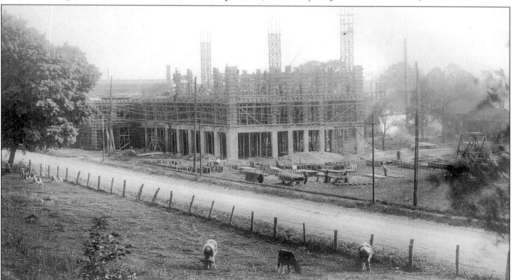

Progress in the construction of the Bosch plant is observed on the north end of Main Street, just before the Chicopee line. Note that Main Street is still unpaved at this time, with a farm across the street from the plant. (Courtesy of Jack O'Donnell.)

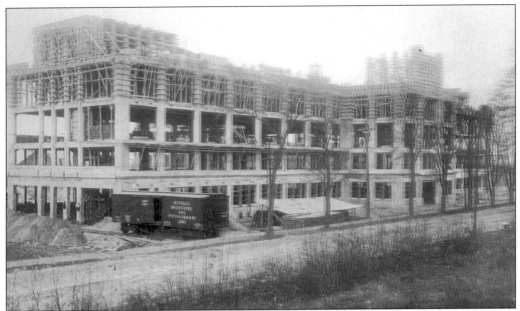

During World War I, the U.S. government realized that the Bosch Company was owned by a German citizen. The stock was impounded and the name of the company was changed to United American Bosch. At the end of the war, the government put the company up for sale and it was bought back by Robert Bosch of Stuttgart, Germany, in 1928. (Courtesy of Jack O'Donnell.)

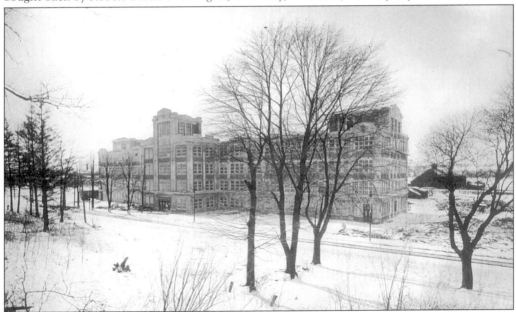

The completed Bosch plant sits amid the winter snow. In 1926, Rudolph Diesel, also a German, took a patent he had for the Diesel engine (an internal combustion engine), and connected with Robert Bosch, who helped to develop a fuel injection system for the engine. After seeing the market for these engines grow in the United States, Bosch started producing them in Springfield, too. (Courtesy of Jack O'Donnell.)

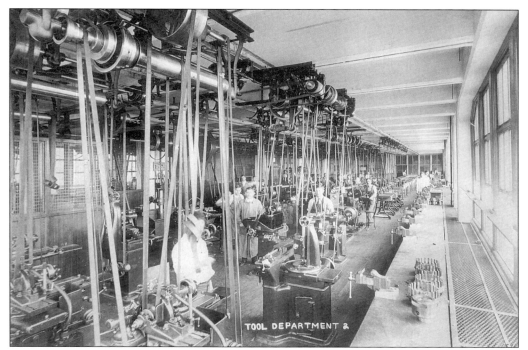

Employees of the Bosch Company's tool department pose *c.* 1910. Years later, after World War II began, the United States government again realized that the Bosch Company was owned by a German and again seized the property. After the war, the company went back on the market and again the Bosch Company in Germany tried to by it, but this time to no avail. The government allowed only established U.S. corporations to bid on it; it was bought by Arma Corporation of Garden City, New York. (Courtesy of Jack O'Donnell.)

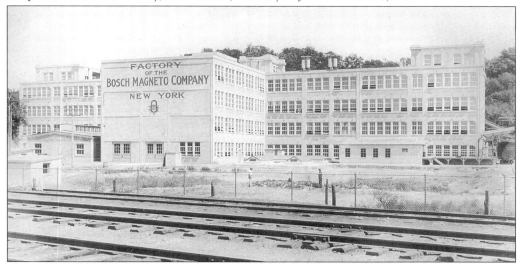

This view shows the original sign of the Bosch Magneto Company. After Arma bought it, the name was changed to the American Bosch Division of Ambac Industries Inc. Arma moved the production of electric motors to a plant in Columbus, Mississippi, *c.* 1955, keeping only the diesel fuel injection line in Springfield. (Courtesy of Jack O'Donnell.)

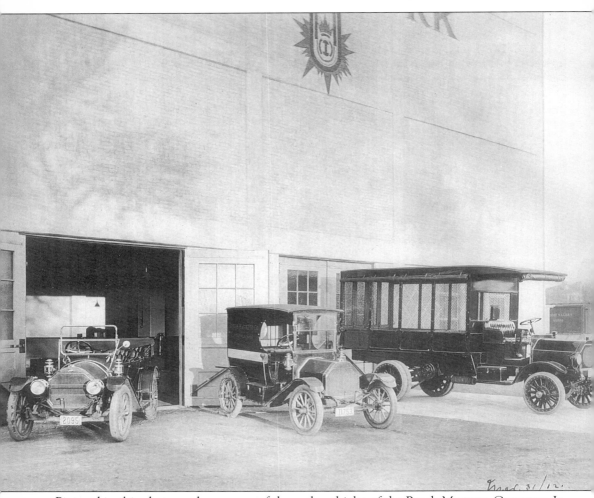

Pictured in this photograph are some of the early vehicles of the Bosch Magneto Company. In 1978, Arma sold the company to United Technologies for $210 million, and the name was changed to the American Bosch Division, United Technologies Corporation. (Courtesy of Jack O'Donnell.)

This view shows the Bosch plant during the flood of March 1936. At the time, factory workers built a pontoon bridge into the second-floor windows and all the equipment that could be saved was hauled up from the first floor to dry off. (Courtesy of Virginia Zabecki.)

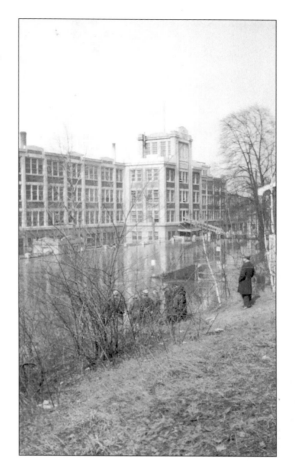

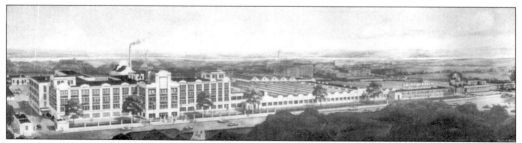

A large addition was constructed at the main plant of the American Bosch Division of Arma to handle the increase in production during World War II. (Courtesy of Jack O'Donnell.)

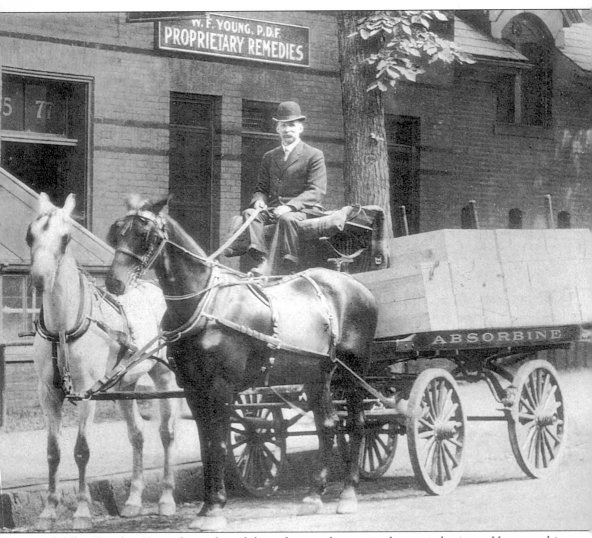

Wilbur Fenelon Young began his adult work as a salesman in the music business. However, his knowledge of horses and medicine, learned as a child, led him to develop a formula made from herbs and oils that would keep a horse from going lame and reduce its swelling and stiffness. Young started selling the liniment to neighbors and local stores. He soon opened a manufacturing operation in Meriden, Connecticut. The business grew, and with a loan from his father, Young moved the operation to a converted barn in Springfield. In 1903, he began to produce a formula for human use: Absorbine Jr. The company outgrew the barn and moved in 1923 to its present location on Lyman Street. Today, a fourth generation of the family runs W.F. Young Inc., and the company's markets exist worldwide. (Courtesy of W.F. Young Inc.)

Big Y, a well-known grocery store chain, was founded in 1936 by Paul and Gerald D'Amour, shown at right. Beginning in Chicopee, they opened their first Springfield store, on Breckwood Boulevard in the mid-1960s. Today, the chain's corporate office is located in a new building on Roosevelt Avenue, where it has been since August 1998. (Courtesy of Big Y Foods Inc.)

This view shows the interior of a Big Y supermarket c. 1950. Today, in addition to its corporate office, the company has a 185,000-square-foot distribution center on Cottage Street and is the largest family-owned and family-operated supermarket in the region, employing more than 7,400 people in 46 locations. (Courtesy of Big Y Foods Inc. and Neil Doherty.)

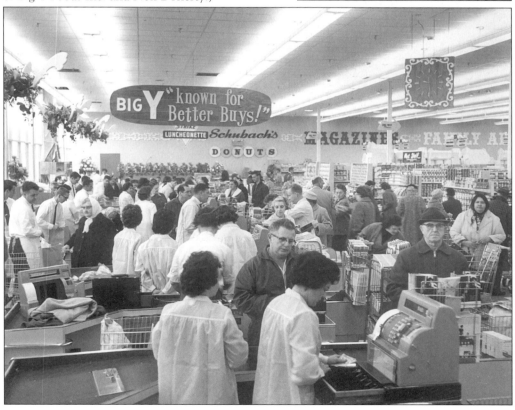

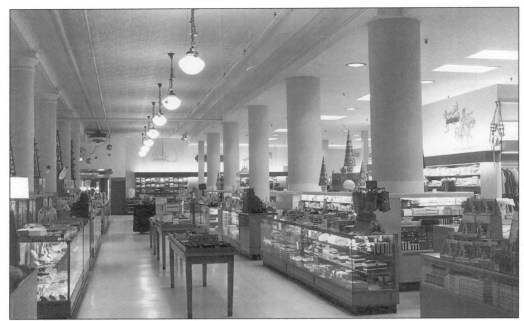

Born in 1860 in Ravensberg, Germany, Albert Steiger began to sell small dry goods in this country at the age of 13. In 1874, he opened a dry goods store in Port Chester, New York, which was followed soon thereafter by a store in Holyoke. This is the interior of the main store in Springfield sometime in the 1950s. (Courtesy of Sheila Herchuck.)

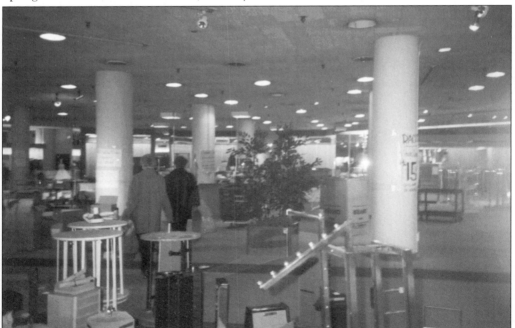

Albert Steiger died in 1938, but his family continued to run the stores. This is the interior of the grand old store on Main Street as its final closing is in progress. The building was torn down in 1995. (Courtesy of Sheila Herchuck.)

For years, Steigers had many loyal employees who loved working for the retail giant. Sheila Herchuck proudly displays her 25-year award from the company. (Courtesy of Sheila Herchuck.)

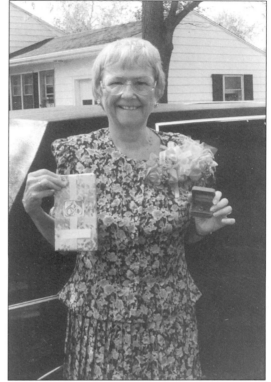

Andrew Wallace, born in Scotland, began another famous Springfield store in 1874 with Alexander Forbes. The store on Main Street served Springfield people for many years. Sadly, the Forbes & Wallace building was torn down, too. These women are at a luncheon of Forbes & Wallace employees. Florence Luthgren is seated second from the right.

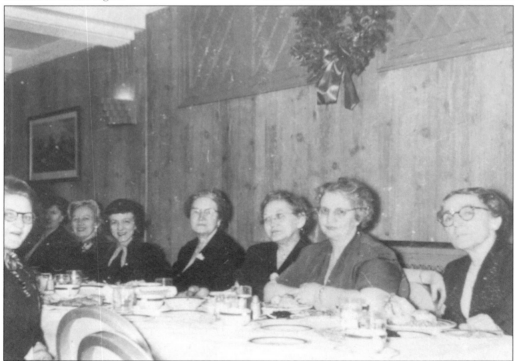

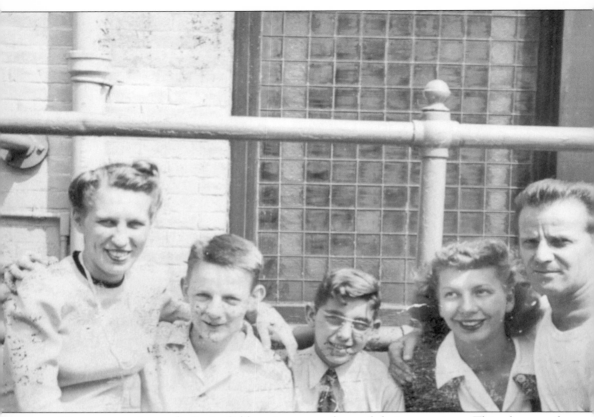

Many companies made Springfield an important base of their operations. This photograph, taken in 1943, shows some employees of the American Optical Company. The adults, from left to right, are Helen Minkalis, Virginia Luthgren Zabecki (mother of the author), and Demetrios Kopycenski. (Courtesy of Virginia Zabecki.)

Three

A SOCIAL CONSCIENCE

The YMCA of Greater Springfield is the second oldest YMCA in North America. Organized in May 1852 in the Old First Church, its first location for meetings was in rented rooms at 451 Main Street, opposite Court Square. This photograph shows the first YMCA building, erected at State and Dwight Streets in 1895 at a cost of $135,000. (Courtesy of the YMCA of Greater Springfield.)

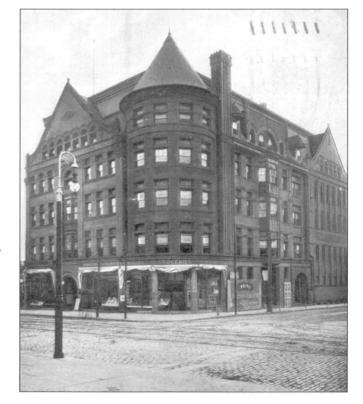

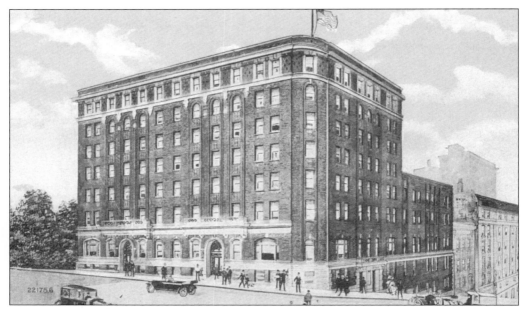

In 1914, a new YMCA was constructed at 122 Chestnut Street, as the organization continued to grow. Considered up-to-date at the time, a new addition was connected in 1919. The Springfield division of Northeastern University, now Western New England College, began in the YMCA building. (Courtesy of the YMCA of Greater Springfield.)

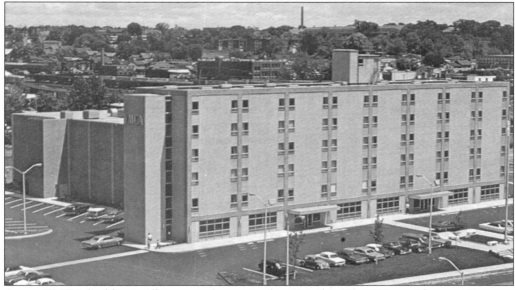

A new YMCA building, still in use today, opened on October 27, 1968, on Chestnut Street at the cost of $36 million, a far cry from the cost of the first structure. Three years earlier, in July 1965, Paucatuck Park Family Recreation Center opened in West Springfield. The YMCA and the park met the goals set by a 1959–1960 self-study that called for a main recreational building in an urban redevelopment area of the city and a year-round family outdoor center outside of the city. (Courtesy of the YMCA of Greater Springfield.)

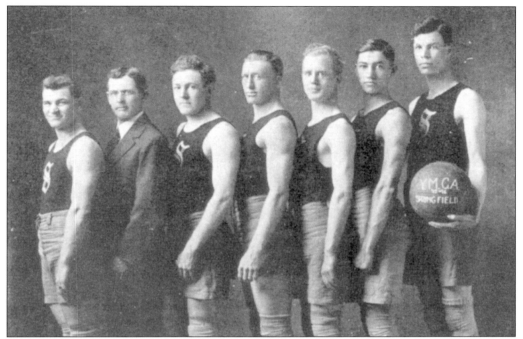

Physical education has always been a major theme of the YMCA, along with self confidence. This early-1900s team proudly poses for a formal shot. Members, from left to right, are (last names only) Parsons, Hardy, Fletcher, Dayton, Manning, Oppenheimer, and Chapin. (Courtesy of the YMCA of Greater Springfield.)

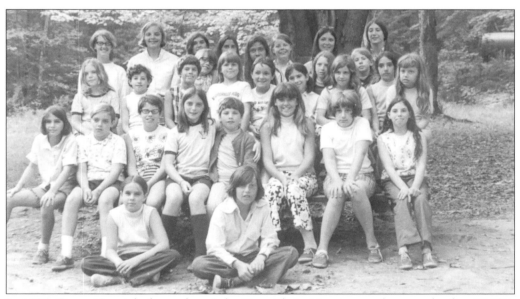

In 1896, Camp Norwich, located on Lake Norwich in Huntington, became the first YMCA camp in New England and just the second in the United States. As the camp grew and buildings were added, girls were allowed to attend, beginning in 1963. These campers attended Camp Norwich in 1969. (Courtesy of the YMCA of Greater Springfield.)

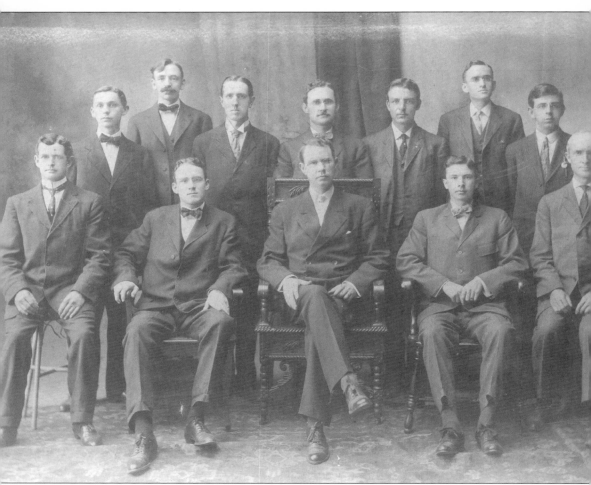

Staff members of the YMCA of Greater Springfield in 1913 are, from left to right, as follows: (front row) Charles W. Hardy, Mr. Rabjent, general secretary William Knowles Cooper, Oliver W. Mulrooney, and Dr. Highley; (back row) L.W. DeGast, Kenneth Robbie, Edward Ambler, Howard W. Russell, Charles Atkins, Robert Crane, and Mr. Cummings. (Courtesy of the YMCA of Greater Springfield.)

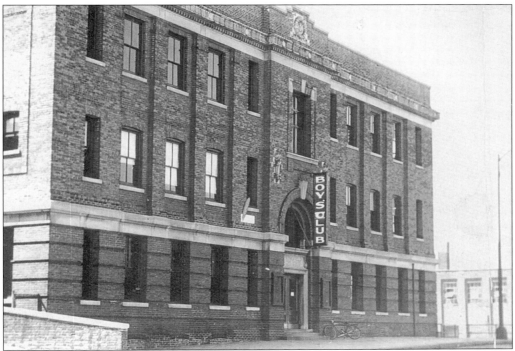

On November 19, 1891, the Springfield Boys Club began in a room above Lubsitz's Bakery on Pynchon Street. In 1896, the club moved to a second location, over Roger's Carriage Shop on Sanford Street. Continued growth necessitated more space, and the first building to be used exclusively by the Boys Club was completed and dedicated on December 14, 1910. Located on Chestnut and Ferry Streets, the new Springfield Boys Club was not hard to finance. The board of directors, headed by Edward F. Bradford, took only five and a half days to raise $62,000. (Courtesy of the Springfield Boys Club.)

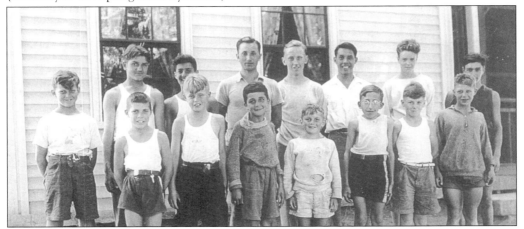

In 1920, John C. Robinson granted the Springfield Boys Club a 110-acre farm in Brimfield as a camp. Gifts from many people (including Charles C. McElwain, Col. J.K. Dexter, Lyman H. Tuttle, Allen L. Appleton, and the Springfield Rotary Club) enabled the development of the camp into a beautiful site. This photograph shows a group of boys who attended the camp in the 1930s. (Courtesy of the Springfield Boys Club.)

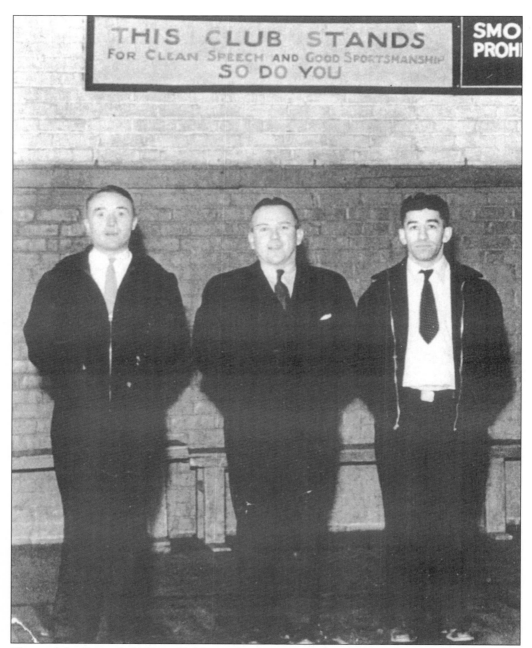

Three of the Springfield Boys Club's past leaders pose in the 1930s in the club facilities. They are, from left to right, Mark Moran, assistant executive director; Paul Sampson, executive director; and Harry Feldman, athletic director. Over the years and continuing today, the club served as a safe haven for many Springfield children. (Courtesy of the Springfield Boys Club.)

The young boys shown here are buying tickets to the club. In its first year of existence, the Springfield Boys Club received financial support from 120 local business and professional people. It was clear that Springfield was committed and dedicated to helping its children. (Courtesy of the Springfield Boys Club.)

These young men are at the Springfield Boys Club in its early years. Many Springfield residents have memories of the club as a wonderful place to go. (Courtesy of the Springfield Boys Club.)

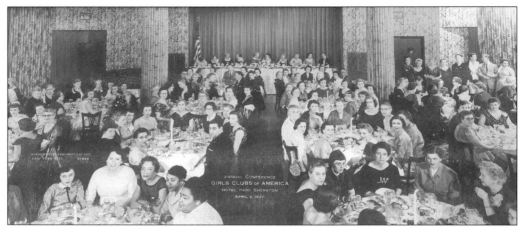

In 1968, the first meeting of the Carew Hill Girls Club was held. For more than 30 years, the club has represented the needs of the city's young women and girls and has shared a building with the Springfield Boys Club. This photograph shows the annual conference of the Girls Club of America in 1957. (Courtesy of the Springfield Boys Club.)

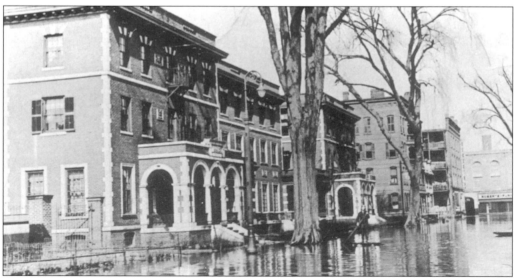

The YWCA of Springfield was founded by 15 volunteers. This photograph, taken during the 1936 flood, shows the Howard Street building that the YWCA first used. (Courtesy of the YWCA of Springfield.)

Attending an early ladies' tea in 1868 are YWCA members, from left to right, Mrs. Hawley, Mrs. Watters, and Mrs. Mellows. They are 3 of the 15 fifteen women who formed the YWCA of Springfield. (Courtesy of the YWCA of Springfield.)

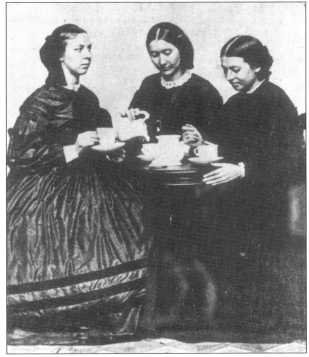

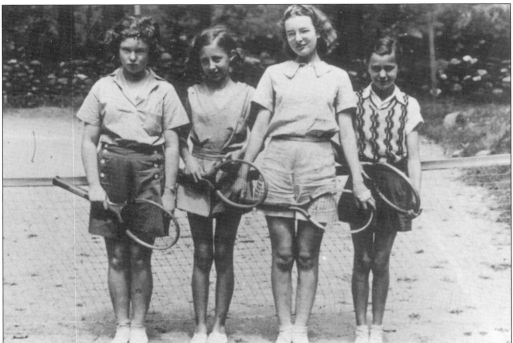

The YWCA of Springfield is the third oldest in the country and the oldest organization for woman in this area. Photographed sometime in the 1940s is a tennis recreation program for young women. (Courtesy of the YWCA of Springfield.)

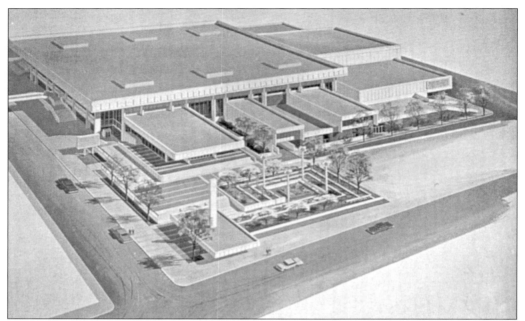

The 10,000-seat Springfield Civic Center and 40,000-square-foot exhibition hall opened on September 22, 1972, with Bob Hope as the first performer. Over the years, countless performances and sporting events, graduations, and exhibitions have taken place in this center. (Courtesy of Victor Tondera.)

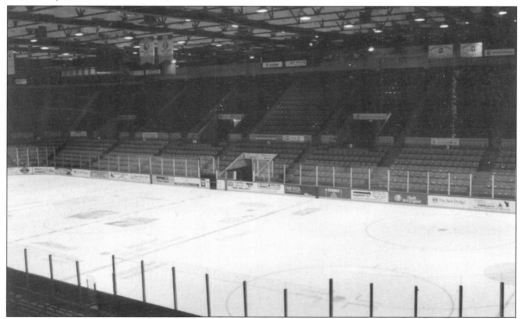

The indoor arena of the Springfield Civic Center has also hosted the National Basketball Association Hall of Fame game, the Tip-off Classic, the Springfield Indians and Falcons games, the Ice Capades, tennis games, and other assorted events. (Courtesy of the Springfield Civic Center & Symphony Hall.)

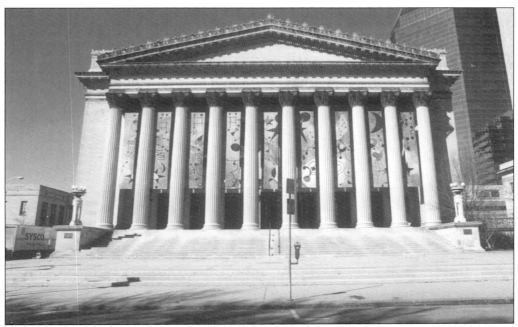

The Springfield Symphony Hall was built in 1900 as the Springfield Municipal Auditorium. It was reopened as the Springfield Symphony Hall in 1980 and now serves as the home of the Springfield Symphony Orchestra, which began in 1944. (Courtesy of the Springfield Civic Center & Symphony Hall.)

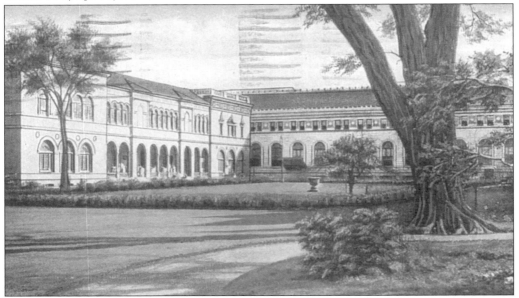

Springfield has a magnificent quadrangle composed of the central branch of the library and four museums. The Science Museum is home to the Seymour Planetarium, the nation's oldest. This is a view of the rear of the library and the George Walter Vincent Smith Museum, which houses major collections of Italian art as well as 18th- and 19th-century Chinese and Japanese art. (Courtesy of Victor Tondera.)

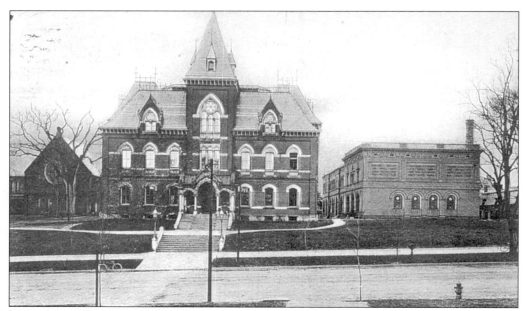

In the late 1800s, Springfield built a new Gothic-style library on State Street. In this view, the library is flanked by Christ Church Cathedral to its left and the George Walter Vincent Smith Art Museum to its right. (Courtesy of Victor Tundra.)

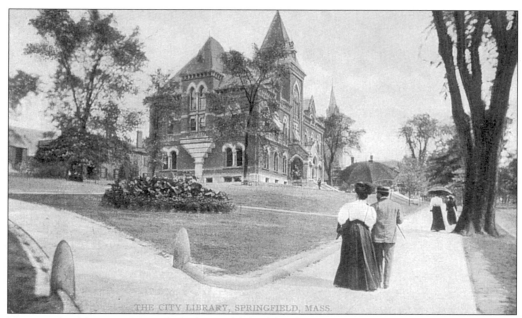

Next to the library is Merrick Park, established by the city in 1899. It became the home of Augustus Saint-Gaudens's *Puritan*, a sculpture of Deacon Samuel Chapin. This library was taken down and replaced in 1912 by the current one, designed in an Italian-Renaissance style. (Courtesy of Victor Tondera.)

Daniel Wesson, a founder of Smith & Wesson, practiced homeopathy and in the early part of the century, founded the Hampden Homeopathic Hospital on High Street, which was to become the Wesson Memorial Hospital. It was not until 1923 that the hospital made a transition from homeopathy to the practice of modern-day medicine. (Courtesy of Baystate Medical Center.)

In 1908, Daniel Wesson established the Wesson Maternity Hospital on High Street. Pictured adjacent to the Wesson Memorial Hospital, the maternity hospital moved to new building on Chestnut Street in 1953 and was renamed the Wesson Women's Hospital in 1969. A brand-new Wesson Women and Infants Unit was opened in 1992. (Courtesy of Baystate Medical Center.)

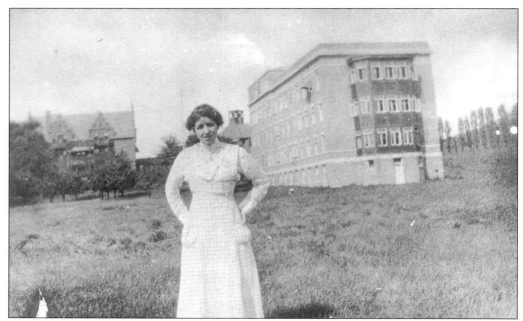

The Springfield Hospital was established in 1883 and moved to Chestnut Street in 1895. This view shows a woman posing in front of the brand-new Chapin Wing, built in 1916. It was not until 1974 that the Springfield Hospital and the Wesson Women's Hospital merged to become the Medical Center of Western Massachusetts. (Courtesy of Baystate Medical Center.)

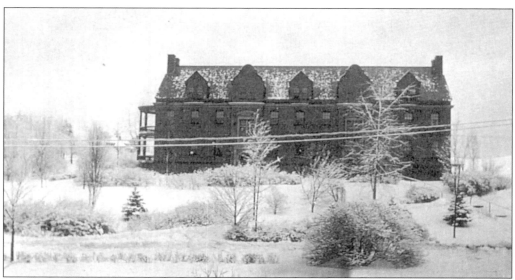

This c. 1916 view shows the nurses' residence, called the Pratt Building, located on Pratt Street. In 1976, the Medical Center of Western Massachusetts and the Wesson Memorial Hospital merged to form the Baystate Medical Center. (Courtesy of Baystate Medical Center.)

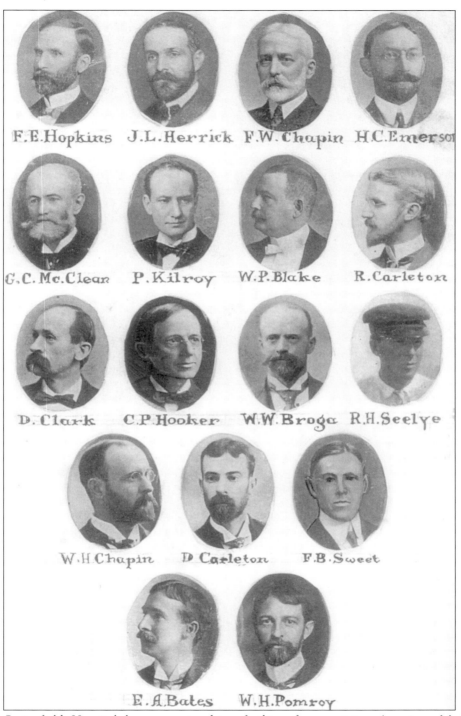

F.E.Hopkins J.L.Herrick F.W.Chapin H.C.Emerson

G.C.Mc.Clean P.Kilroy W.P.Blake R.Carleton

D.Clark C.P.Hooker W.W.Broga R.H.Seelye

W.H.Chapin D Carleton F.B.Sweet

E.A.Bates W.H.Pomroy

The Springfield Hospital became a teaching facility after receiving American Medical Association approval for training interns in 1914. Shown is the staff in 1903. (Courtesy of Baystate Medical Center.)

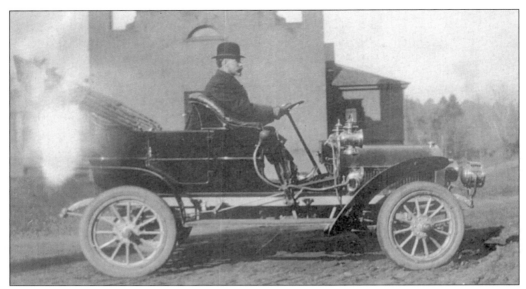

Dr. Frederick E. Hopkins of the Springfield Hospital poses in his new 1905 Stevens-Duryea car. (Courtesy of Baystate Medical Center.)

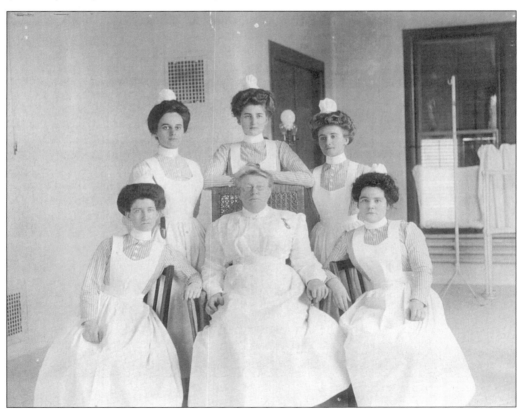

The nursing staff poses in the Wesson Maternity Hospital *c.* 1910. It is uncertain what school the nurses came from—possibly the North Adams School. (Courtesy of Baystate Medical Center.)

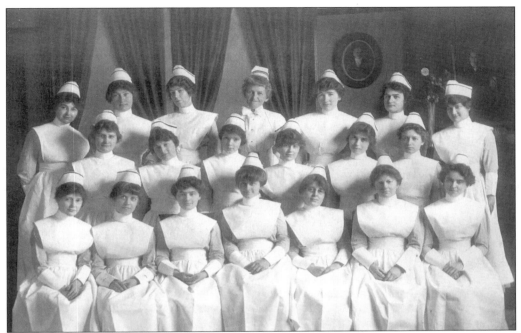

Today, the Baystate Medical Center is recognized as a major teaching and research facility, with more than 240 residents and more than $9.7 million in sponsored research. It is the Western Campus of Tufts University School of Medicine. This class from the Springfield Hospital School of Nursing poses in 1917. (Courtesy of Baystate Medical Center.)

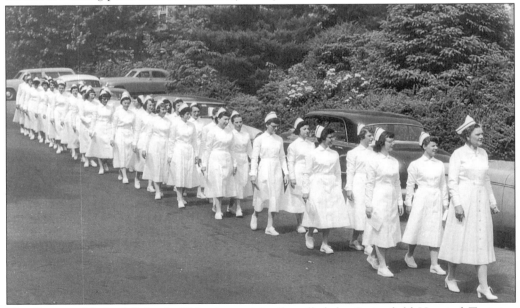

The Baystate Medical School of Nursing, originally called the Springfield Hospital Training School for Nursing, opened in May 1892 with six students. Here, the Class of 1956 walks to the graduation ceremony from the nurses' residence. The school graduated its last class in 1999. (Courtesy of Baystate Medical Center.)

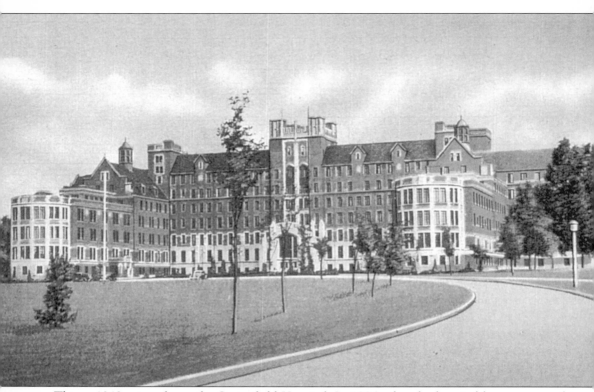

This c. 1940s view shows the Springfield Hospital. In 1986, after the hospital became part of the Baystate Medical Center, the Centennial Building was added to the original hospital. (Courtesy of Baystate Medical Center.)

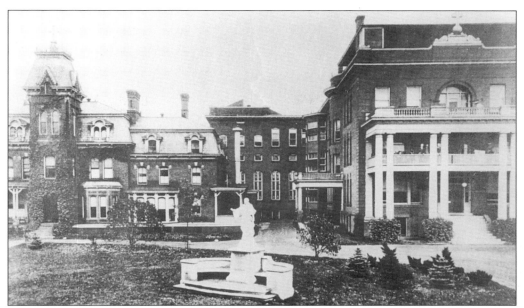

Established in 1896, the Mercy Hospital began when Dr. Walter A. Smith purchased the home of Waitstill H. Allis on Carew Street in order to convert it into a hospital for the poor. When Mercy Hospital later passed into the hand of the Springfield Catholic Diocese, the Sisters of Providence began to administer the facility. It was then called the House of Mercy. It became Mercy Hospital in 1898, and the cornerstone was laid for a new 150-bed building nicknamed "the General." (Courtesy of Sisters of Providence Health System.)

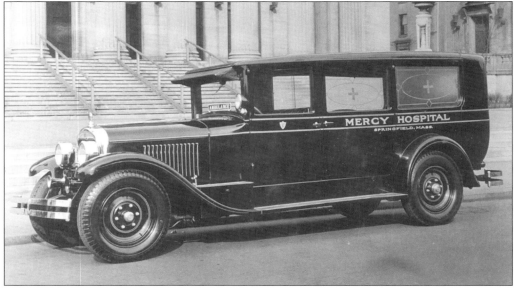

This ambulance was proudly displayed as a piece of modern equipment for the hospital in the early part of the 20th century. Mercy Hospital continued to grow, and by 1970, plans were made for a new 300-bed hospital to be built on an adjacent site. Ground was broken in 1972, and with corporate and private assistance, the project was soon completed. (Courtesy of Sisters of Providence Health System.)

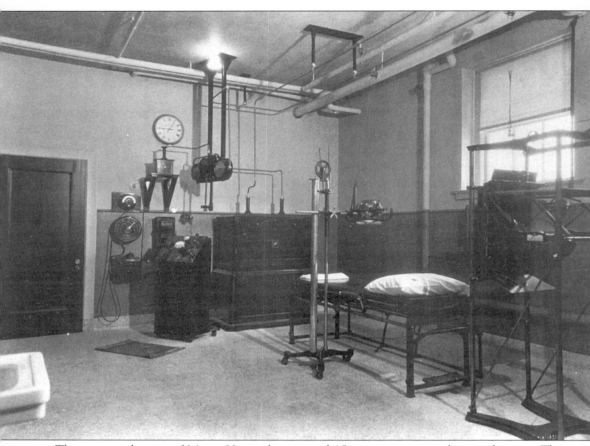

The new north wing of Mercy Hospital contained 15 patient rooms and surgical rooms. This view shows how an X-ray room looked in a modern facility in 1943. (Courtesy of Fred Leblanc.)

Mercy Hospital opened its school of nursing in 1900. In August 1903, the first class of five graduated. This young nurse is shown sometime in the early 1900s in a very modern and progressive St. Mary's Maternity Hospital, which had 30 beds and 36 bassinets. St. Mary's was established in 1907. (Courtesy of the Sisters of Providence Health Systems.)

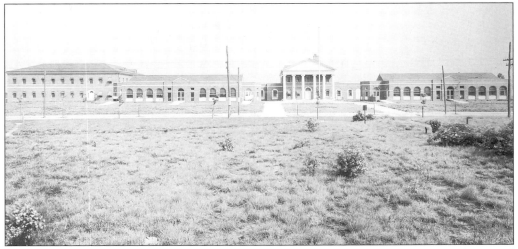

Ten Shriners Hospitals were already built in the United States when the Imperial Council began to look for a location for a new hospital in the Northeast. The Melha Temple in Springfield had 7.5 acres of land on Carew Street, which it hoped would become the site for the 11th hospital. On its way to look at land in Boston, the site committee from Chicago stopped in Springfield. The committee was met by many Melha representatives who, riding in borrowed Rolls Royce limousines, attempted to convince them to build in Springfield. (Courtesy of Shriners Hospital for Children, Springfield.)

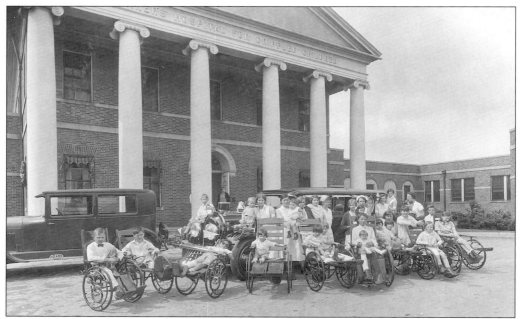

After much fanfare, the site committee from Chicago chose to build the new hospital on the 7.5 acres of land on Carew Street. Construction began in 1924, and the hospital opened on February 21, 1925. It was a 50-bed hospital with an outpatient department. This mid-1920s photograph shows some of the hospital's young patients and their nurses. (Courtesy of the Shriners Hospital for Children, Springfield.)

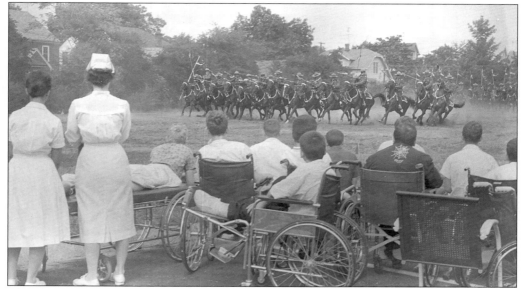

The Shriners Hospital treated children from New England and many other areas. Orthopedic surgeons being trained at the hospital through a residency program helped supply trained physicians in this field to the entire country. In this 1940s photograph, the Royal Canadian Mounted Police perform on the hospital's lawn for the children. (Courtesy of the Shriners Hospital for Children and Ralph Bacon.)

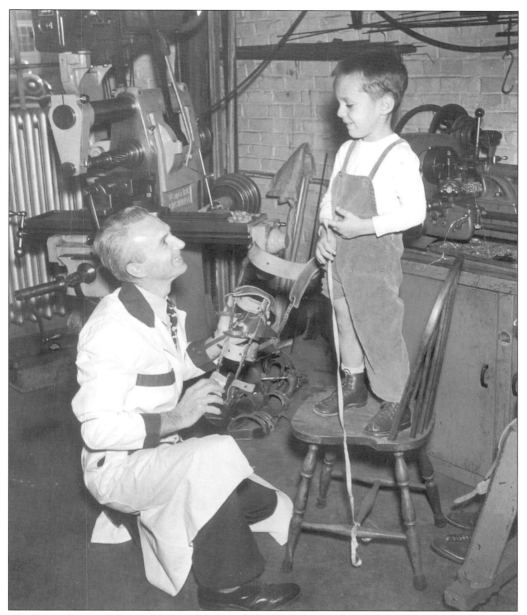

The new Shriners Hospital boasted a dental clinic and an orthotic department, which was for making leg braces. In this 1920s photograph, a young child is being fitted for a leg brace. (Courtesy of the Shriners Hospital for Children, Springfield.)

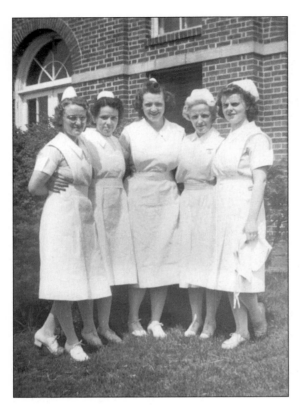

A group of nurses poses in front of the hospital, c. 1950. In 1988, a groundbreaking ceremony for a new hospital took place. On September 29, 1991, the new hospital was dedicated. (Courtesy of the Shriners Hospital for Children, Springfield.)

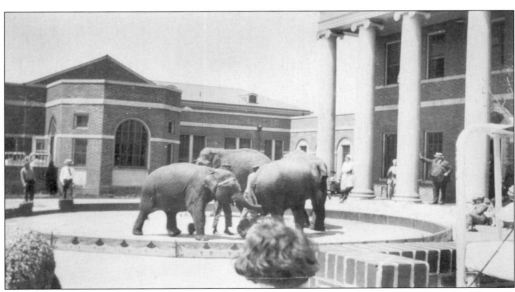

When performing in the Springfield area, the Melha Circus always makes a stop at the Shriners Hospital. Elephants in the ring parade for children in front of the hospital, c. 1930s. (Courtesy of the Shriners Hospital for Children, Springfield.)

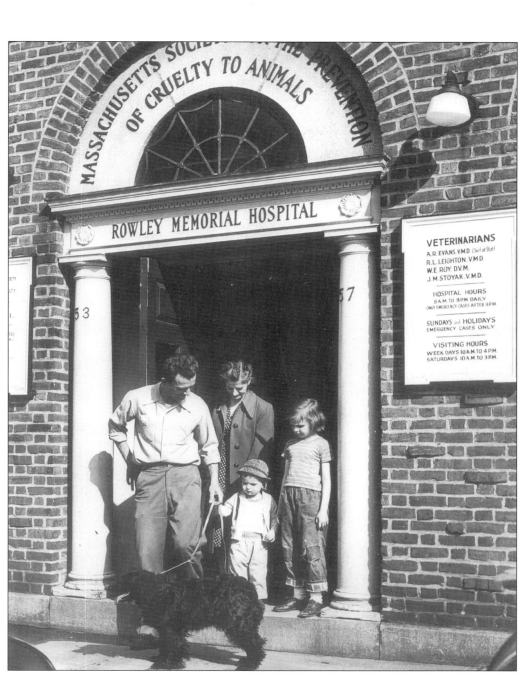

George Thorndike Angell founded the Massachusetts Society for the Prevention of Cruelty to Animals in 1868 and the American Humane Education Society in 1889. He was succeeded as president of the society by the Reverend Francis Rowley. In 1914, Angell helped to establish an animal shelter in Springfield. In 1931, a shelter and hospital were constructed on Bliss Street. Here, a family emerges with their pet dog from that facility in the 1950s. (Courtesy of the MSPCA/AHES.)

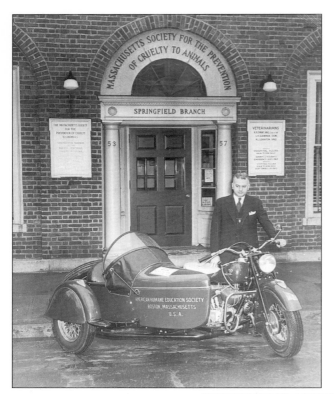

When he founded the humane society, George Angell felt that teaching both adults and children about compassion, kindness, and respect for life would produce a better world for everyone. Shelters were established for abused, neglected, and abandoned animals to promote a better understanding of the humane treatment of horses, commonly used then for work and transportation. In this photograph, a doctor of the facility poses with a vehicle used in the city. (Courtesy of the MSPCA/AHES)

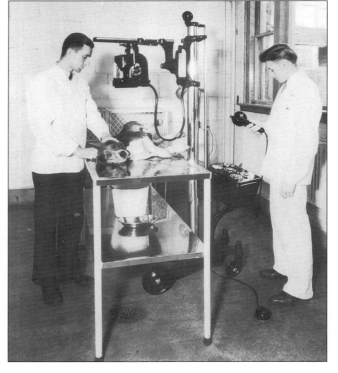

This is a 1933 examining room, showing the latest in veterinary medicine. Throughout the years, the hospital's reputation as a teaching facility has allowed it to attract many fine veterinary interns. The facility today employs more than 100 people full time. (Courtesy of the MSPCA/AHES.)

These two doctors are shown in 1957 working with a Chihuahua. The Rowley Memorial Animal Hospital began with one veterinarian on staff in 1931 and now has 15 who treat more than 21,000 animals each year. (Courtesy of the MSPCA/AHES.)

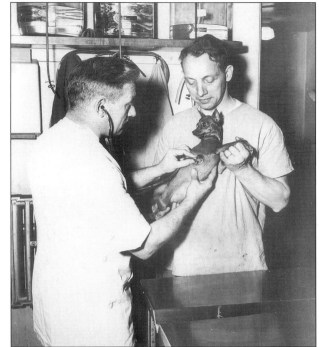

This doctor is receiving two patients and their owners, c. 1950, into the Rowley Memorial Hospital. Today, animals receive state-of-the-art veterinary care in many specialties, such as internal medicine, surgery, ophthalmology, and cardiology. (Courtesy of the MSPCA/AHES.)

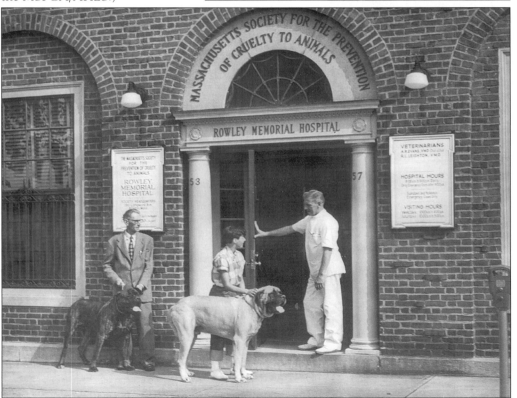

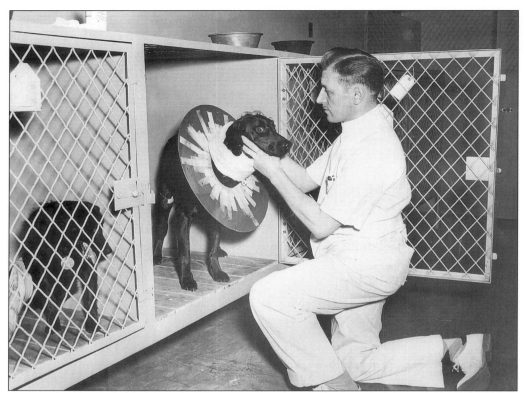

While the MSPCA/AHES cares for animals in the hospitals, they also oversee hundreds of animal adoptions each month and continue to educate the public on the humane treatment of wildlife and pets, pet population control, and responsible pet ownership. (Courtesy of the MSPCA/AHES.)

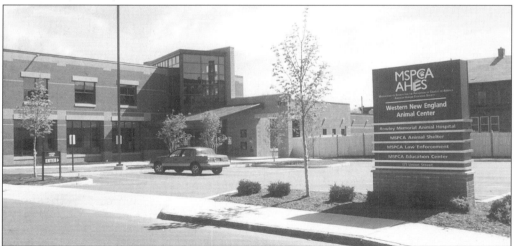

In 1998, a new $10.5 million Western New England Animal Center opened in downtown Springfield. Located on 2.5 acres, the new building has 46,700 square feet of space. Patients are served 24 hours a day, 7 days a week in this animal center—one of the newest and finest in existence. (Courtesy of the MSPCA/AHES.)

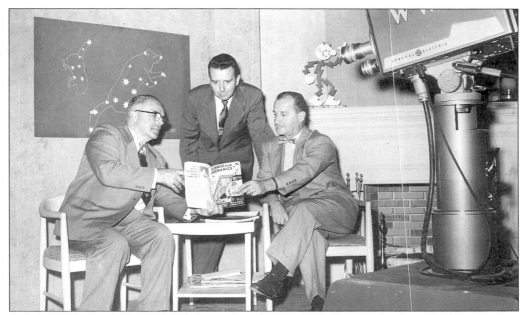

In June 1952, the Springfield Television Broadcasting Corporation was formed and opened its offices on Chestnut Street in Springfield. In July of the same year, a license to operate on Channel 61 was granted to WWLP-TV. Tom Colton, center, was the host of the program *Western Massachusetts Highlights*, which began airing in 1953 and featured interviews with prominent area people. (Courtesy of WWLP.)

In October 1952, the race was on between local stations to be the first one on the air in western Massachusetts. On March 1, 1953, WWLP-TV transmitted the first television signal in that area. On March 17, 1953, the station initiated its first commercial broadcast. WHELP was one of the first UHF stations in the country and the first in Massachusetts. Ed Kennedy, WWLP's first news director, is shown interviewing people on Main Street in Springfield. (Courtesy of WWLP.)

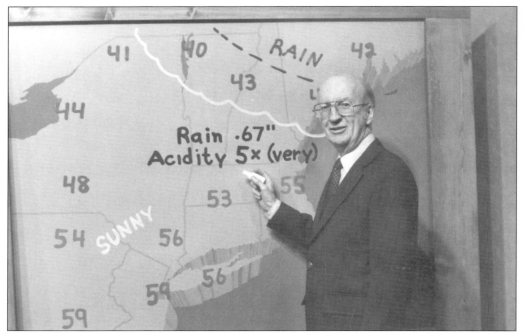

John Quill broadcast the first local televised weather forecast at 7:10 p.m. on March 17, 1953. The meteorologist has been with WWLP since the beginning. Today, he has the distinction of being the oldest weather person continually on the air at one station. (Courtesy of WWLP.)

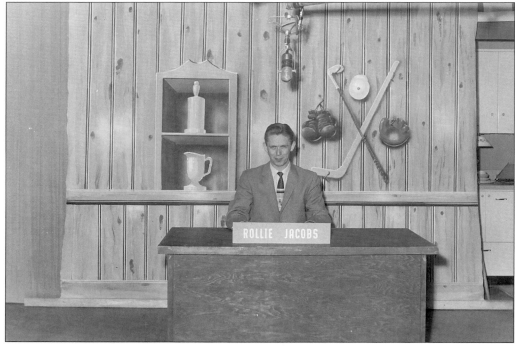

Rollie Jacobs served for may years as the sports director at WWLP. Jerry Healy was the station's first sports director. (Courtesy of WWLP.)

Four

THE SPORTING LIFE

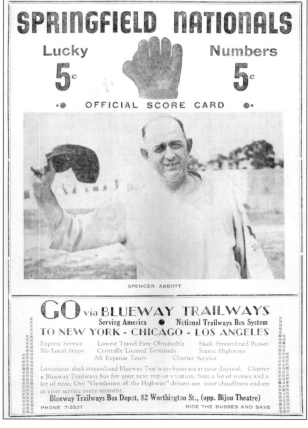

SPENCER ABBOTT

For many years, Springfield had a minor league baseball team, which played at Pynchon Park. The first team was the Springfield Hampdens in 1893. This program dates from the time that the team was called the Springfield Nationals, in 1939, 1940, and 1941 while it was affiliated with the Washington Senators. From 1922 to 1932, Springfield's team was affiliated with the Yankees and was called the Springfield Yankees. (Courtesy of Joe Perla.)

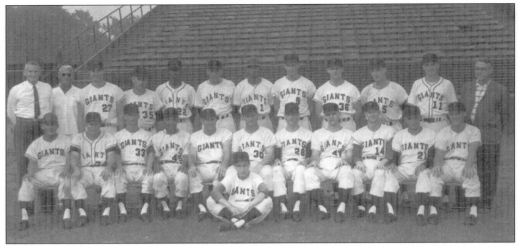

This team photograph of the Springfield Giants was taken in 1958 at Pynchon Park. The team was known as the Giants from 1957 to 1965, when it was a farm team of the San Francisco Giants. Pictured here, from left to right, are the following: (front row) Jose Pagan, Frank Reveria, Ernie Bowman, Johnny Weekly, Jack Lewis, manager Andy Gilbert, Roy Wright, Ed Herstek, Vic Davis, Julio Navarro and George Case; (back row) business manager Chick O'Malley, trainer Ed Potsavage, Rudy Hernandez, Pat Enos, Charlie Dees, Jim Duffalo, Bob Perry, Dick Lemay, Larry Cummings, Roger McCardell, Chet Vincent, and general manager Charles Stoneham. On the ground is batboy Gary Moltenbrey. (Courtesy of Joe Perla.)

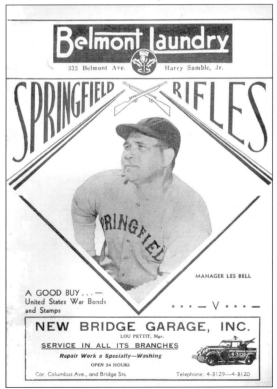

While it was still affiliated with the Washington Senators, the team had a name change in 1942 and in 1943, it became the Springfield Rifles. This program dates from that time. The famous Walter "Rabbit" Maranville was the manager of the Springfield team in 1948–1949. (Courtesy of Joe Perla.)

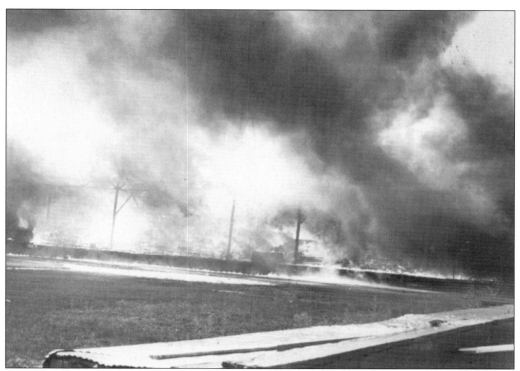

The last year that semipro baseball games were played at Pynchon Park was 1965. A few years later, the park was destroyed by fire and is now the site of the farmers market area on Avocado Street. (Courtesy of Joe Perla.)

Ralph W. Ellis, Springfield's ex-mayor, throws out the first pitch to officially open the baseball season in 1902. At that time, the Springfield team was part of the Connecticut State League. (Courtesy of Jack Hess.)

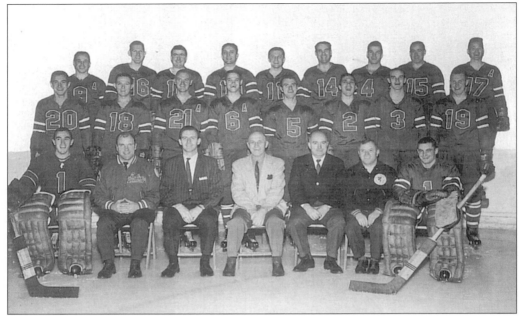

Semipro hockey also has a wonderful history in Springfield. The old Springfield Indians began with owner Eddie Shore. The team had four changes in ownership: the Los Angeles Kings, Eddie Shore again, Mr. Leary, and Peter Cooney. (Courtesy of Jack Hess.)

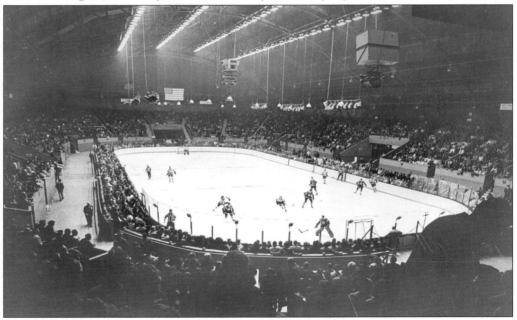

The Springfield Indians first began playing at the arena at the Eastern States Exposition, the scene of this game. The team moved from there to the Springfield Civic Center in the 1960s, back to the Eastern States for a time, and then back to the Springfield Civic Center in the 1980–1981 season. The Falcons still play at the Springfield Civic Center. (Courtesy of Peter Cooney, Springfield Indians Hockey Club Inc.)

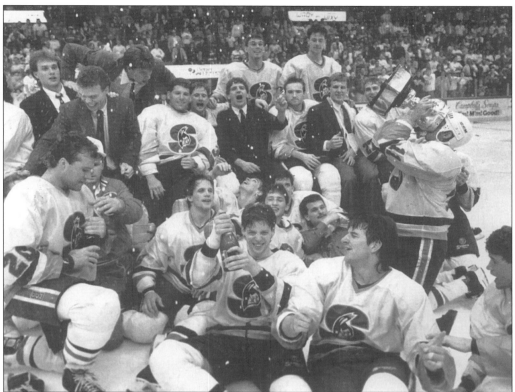

Peter Cooney took over as owner of the Springfield Indians in the 1982–1983 season and had the team for 12 years. Over the years, the team has won seven Calder Cups, three times in a row, a feat never accomplished before nor since. This photograph shows the win in the 1989–1990 season. (Courtesy of Peter Cooney, Springfield Indians Hockey Club Inc.)

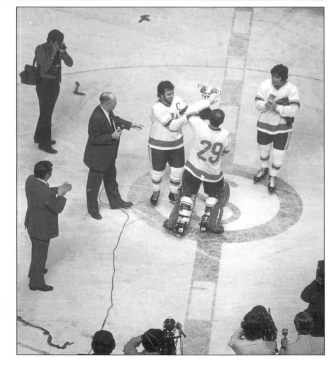

The Springfield Indians win the Calder Cup in 1975. Jack Butterfield, president of the American Hockey League, poses with Indians captain Mark Heaslip, goalie Rick Charron, and Tom Cassidy. (Courtesy of Peter Cooney, Springfield Indians Hockey Club Inc.)

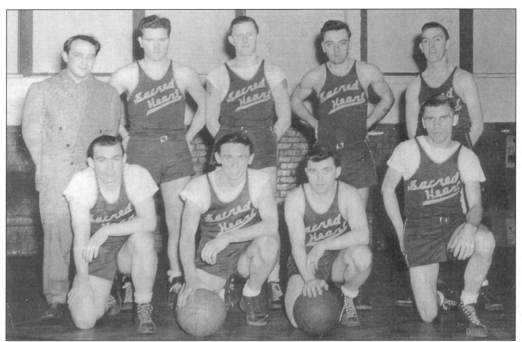

Springfield is famous as the home of basketball. In *Springfield: Volume I*, Dr. Naismith's first team appears, and the game's roots at Springfield College are portrayed. However, the city's love of basketball extended in many directions. At one time, every group, school, business, and organization seemed to have a basketball team. This *c.* 1950s team was sponsored by the Sacred Heart Church, and includes, from left to right, the following: (front row) Billy Sultan, George Brown, Jack Cavanaugh, and Mike Cavanaugh; (back row) Tommy Splaine, Bill Kennedy, Owen Hess, Bob Crowe, and Gene Sullivan. (Courtesy of Mallaci Fallon.)

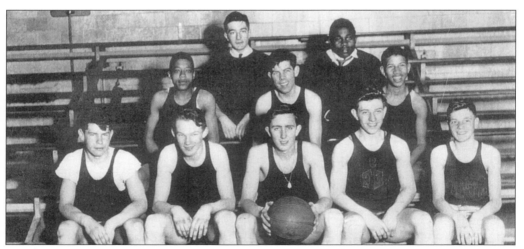

Another team from the 1950s includes, from left to right, the following: (front row) Andy Fenton, Dan Manning, Bob Langlands, Stanley Pagourgis, and Billy Maggi; (middle row) Irving Hall, Bud Wynn, and Wizer Gaskins; (back row) coach Tom O'Connor and Emmett Smitty. (Courtesy of Mallaci Fallon.)

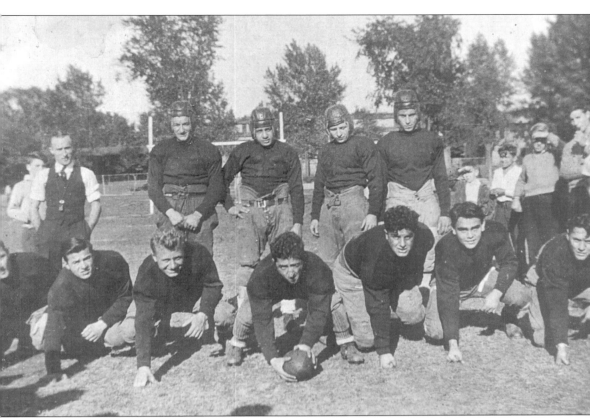

Many organizations also had football leagues. This 1942 photograph shows an Italian league from the city's south end, which included, from left to right, the following: (front row) Alex Pettazoni, Willie Collina, Primo Guidi, Gus Maltoni, Mr. Genga, Joe Cocchi, and Albert Baldini; (back row) Spike Berselli, Mario Cocchi, Blacke Pallazzi, Mike Stroghopetti, and Perino Salvetti. (Courtesy of the Adriatic Club.)

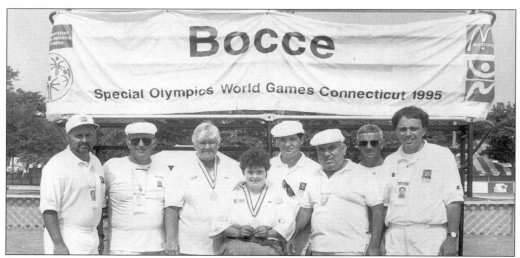

The first bocce league began in Springfield in 1932. Founded by Pat Morisi, the league continues today. The game was played for the first time ever in the 1995 Special Olympic World Games. This photograph shows Rico Daniele of Springfield, far right, who has devoted himself to the game. Both he and Robert Markel, a former mayor of Springfield, participated in the opening-day ceremonies. (Courtesy of Ed Cohen and Rico Daniele.)

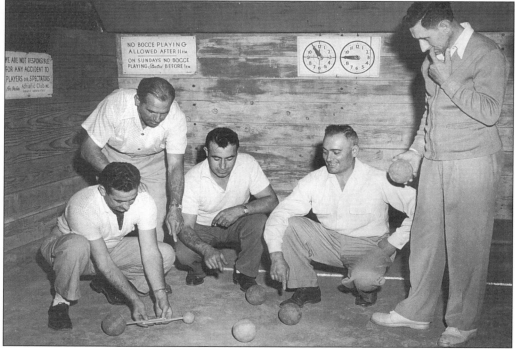

Bocce, as a sport, may have been played by the early Romans, using coconuts brought from Africa. It is certain, however, that the game was a popular European pastime for centuries. Italian immigrants brought the game to Springfield with them. This 1953 photograph shows members of the Adriatic Club playing the game. Kneeling in the center is Aldo Palazzi, and standing at the right is Don Tebaldi. (Courtesy of the Adriatic Club.)

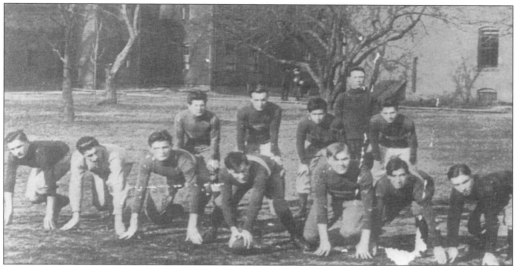

This 1909 view shows an early American International College football team. Throughout the years, Springfield's colleges have participated in all aspects of team sports. (Courtesy of American International College.)

A local Gaelic soccer team poses in 1960 after just winning the Southern New England Gaelic Football Championship. Shown, from left to right, are the following: (front row) John Grummel, Owen O'Donnell, Paul Reiley, Pat McIntire, and John O'Shea; (middle row) John Martin, Jerry Murphy, Paul Reiley, Mike Mulligan, Brandon Baker, Mike Fitz, and Thomas Sears; (back row) treasurer Pat Mangan, Mike Hennigan, Dennis O'Shea, Henry O'Connor, Michael Sears, John Ashe, Mike Garvey, and manager and president of the league Mike Carney. (Courtesy of Mike Carney.)

This 1937 photograph shows the YMCA Olympians posing at the old YMCA. These young men are part of a youth basketball league, which had members from the Greek Orthodox Church.

Another youth basketball team from 1938 was a group from Van Horn Park. Included, from left to right, are the following: (front row) ball boy Mac McKenzie, Chappie Garvey, Jack Abair, Red Murphy, and Jerry O'Connor; (back row) Ed Dowd, Dan Dowd, Ed Szydlo, and Toss Shea. (Courtesy of Red Murphy.)

Sports were very important to the community. Young children began then, as they do now, to be interested as soon as they could hold the equipment. Ar right, Oscar Luthgren poses in 1924 in his uniform. Below, his young son, Elwin Luthgren, holds dad's glove and poses in the same field.

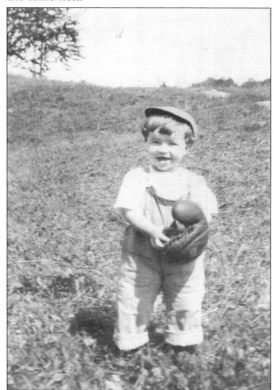

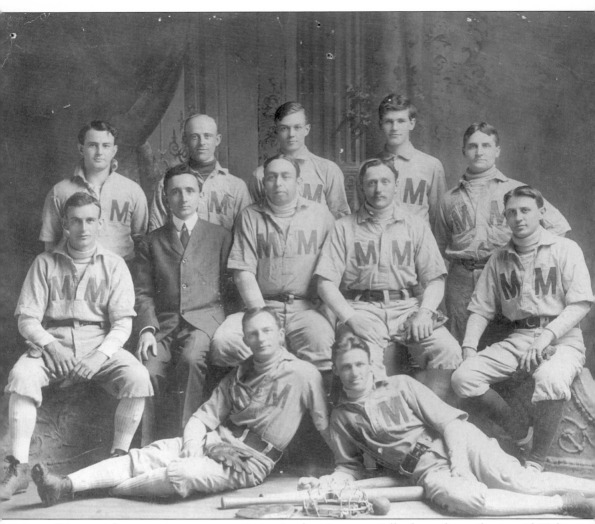

Company leagues were very prominent in the city, especially from the early to mid-20th century. This is a baseball team from the Massachusetts Mutual Life Insurance Company in 1906. They are, from left to right, as follows: (front row) O.E. Hovis and William E. Ryan; (middle row) Ted Davis, manager Joseph J. Jennings, Bernard E. Graves, Herman F. Foerster, and Bertram W. Smith; (back row) Tom Dowd, Albert D. Shaw, Webb Crowther, Bill Porter, and Joseph C. Behan. (Courtesy of Massachusetts Mutual Life Insurance Company.)

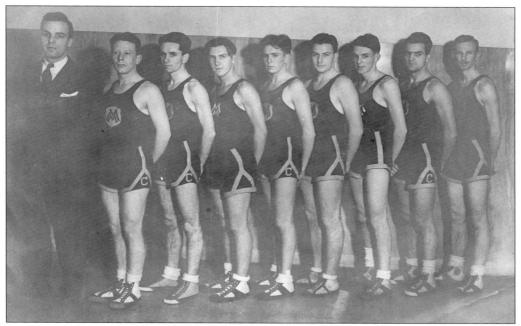

Shown is an early Massachusetts Mutual Life Insurance Company basketball team. They are, from left to right, C. Dawton, N. Martini, B. Albro, Unito Turman, H. Hayden, Ed Hulton, V. Grennan, H.F. Frisbie, and C. Morgan. (Courtesy of Massachusetts Mutual Life Insurance Company.)

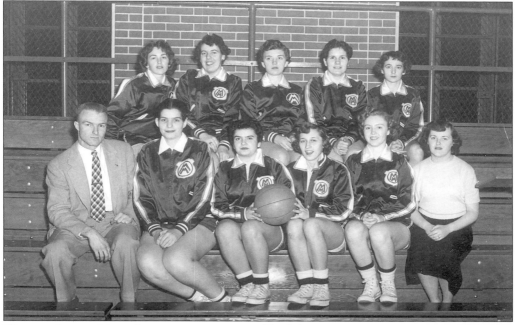

Women also participated in company sports and had their own competitive teams. This team of ladies from the Massachusetts Mutual Life Insurance Company poses in 1954. (Courtesy of Massachusetts Mutual Life Insurance Company.)

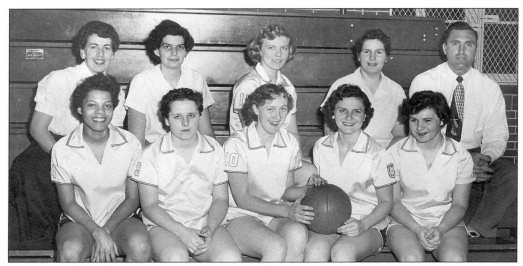

Sporting newer uniforms and high-top sneakers, this Massachusetts Mutual Life Insurance Company team poses in March 1957. The Business, Industrial, and Commercial League in the city pitted many prominent companies against each other. This women's basketball team played against teams from Westinghouse, State Mutual, Westover Women Air Force members, and others. (Courtesy of Massachusetts Mutual Life Insurance Company.)

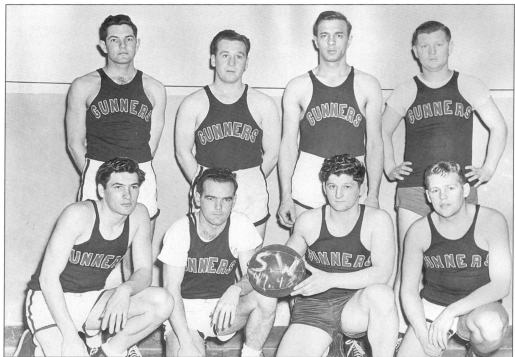

Another company that competed in many sports was Smith & Wesson. This is Smith & Wesson's 1948 Gunners, who played in the AAA League against teams from Package Machinery, General Electric, and the Springfield Armory. In the back row on the far right is Vincent Korzeniowski. (Courtesy of Michael Korzeniowski.)

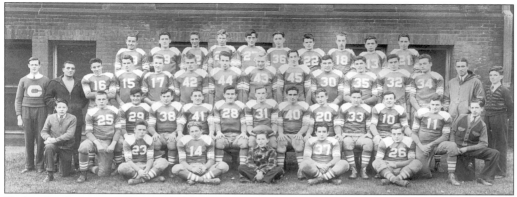

High school sports in the city hold memories for everyone. In 1939 and 1940, Cathedral High School football players were the city champions. Angelo Bertelli, who went on to play for Notre Dame and won the Heisman Trophy, was on that team. The players pictured, from left to right, are as follows: (first row) No. 23 Brendan Wynn, No. 14 Alex Savenko, No. 37 Tom Dolan, and No. 26 John Massey; (second row) No. 25 Quinn, No. 29 Pete Fortin, No. 38 Ray Dumas, No. 41 Doyle, No. 28 D. McCarthy, No. 31 Angelo Bertelli, No. 40 Pete Lamana, No. 20 Hart, No. 33 Hogan, No. 10 Heroly, and No. 11 Keough; (third row) No. 16 Martelli, No. 15 J. Murphy, No. 17 unidentified, No. 42 J. Pipal, No. 44 Mike Murphy, No. 43 Jim Foley, No. 45 Ed McCaffrey, No. 30 Ted Budnykiewcz, No. 35 John Sullivan, No. 32 W. Webber, and No. 34 Isidore Yergeau; (fourth row) Bob Pasini, John Kenny, Stanley Ragion, three unidentified players, No. 22 Jack Dwyer, and the remaining unidentified. (Courtesy of Cathedral High School.)

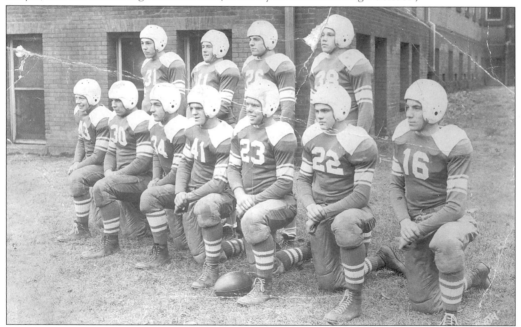

The Cathedral High School starters of the 1940 championship team, from left to right, are as follows: (front row) No. 43 James Foley, No. 30 Ted Budnykiewicz, No. 34 Yergeau, No. 41 Houlihan, No. 23 Wynn, No. 22 Dwyer, and No. 16 Martinelli; (back row) No. 31 Jerry O'Connor, No. 11 Frances Keough, No. 26 Tom McCarthy, and No. 38 Bob Sullivan. (Courtesy of Cathedral High School.)

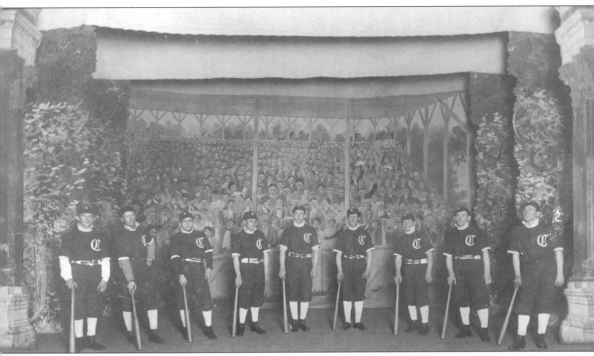

This vintage photograph shows Cathedral High School's first baseball team in 1909, which was organized by Rev. John A. Quigley. Pictured, from left to right, are Jim Germain, John Dowd, Bob Kelliher, J. Murphy, John Norman, Irvine McDonald, Gerald O'Neil, Jack McCarthy, and Richard Hennessey. (Courtesy of Cathedral High School.)

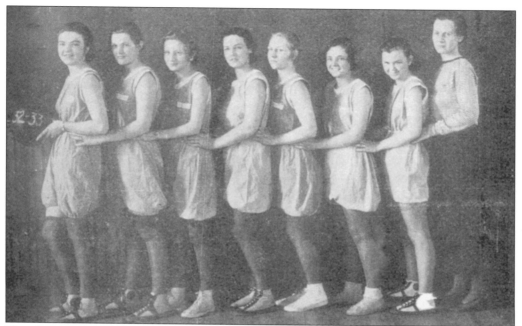

The Cathedral High School girls' basketball team of 1932–1933 included, from left to right, Mary Ellen Quility, Francis Enright, Mary Sullivan, Agnes McNally, Julia Kelly, Sis Duyard, Mary Ferris, and Miss Crowley. (Courtesy of Cathedral High School.)

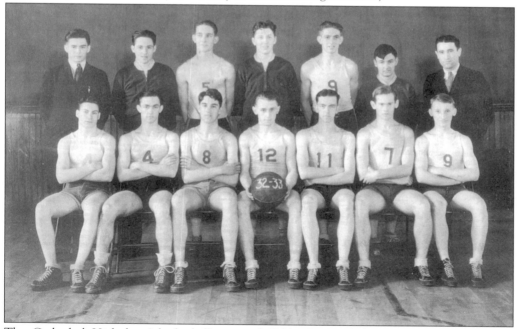

The Cathedral High boys' basketball team of 1932–1933 included, from left to right, the following: (front row) unidentified, Ernie Hanson, Eddie Connely, Mike Carney, Tom Burke, Bob Fisk, and John Leur; (back row) unidentified, John Donnahue, Danny Crowley, Bud Fitzgerald, "Stretch" Wright, unidentified, and coach Billy Wise. (Courtesy of Cathedral High School.)

Cathedral High School's first track team includes, from left to right, the following: (front row) Carney, Lyons, and Leahy; (back row) Adams, Symonick, Gorman, Kennedy, and Diehl. (Courtesy of Cathedral High School.)

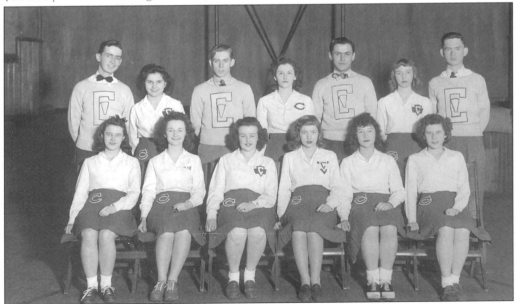

This photograph shows the Cathedral High School cheerleaders of 1943–1944. (Courtesy of Cathedral High School.)

114

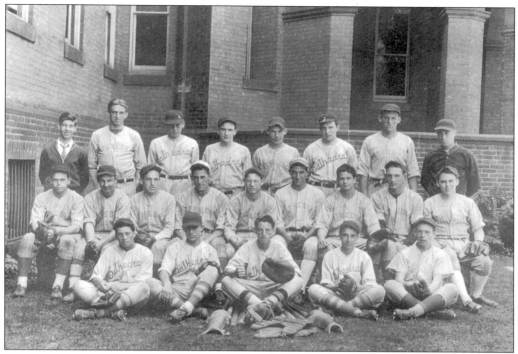

The 1934 Parochial League champions in baseball were from Cathedral High School. Members of that team included (in no specific order) John "Okie," Charles Loiselle, Gene Sullivan, Ray Lameurux, Bobby Triggs, Dan Crowley, John Coffey, "Stretch" Wright, ? O'Herron, Joe Kennedy, Fred Stocks, ? McGuire, Don Reidy, Charlie Hebert, Pat Pepper, Tony King, and Alfred Lemoine. They were coached by Billy Wise. (Courtesy of Cathedral High School.)

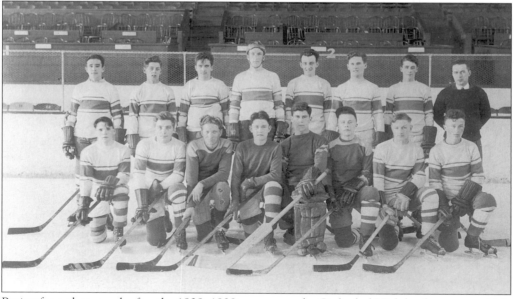

Posing for a photograph after the 1938–1939 season was the Cathedral High hockey team, which won the Western Massachusetts championship that year. (Courtesy of Cathedral High School.)

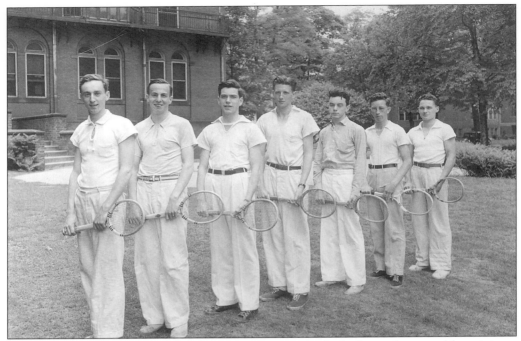

Cathedral High School expanded the types of sports in which the students could participate and compete. This photograph shows Cathedral's 1937 tennis team. (Courtesy of Cathedral High School.)

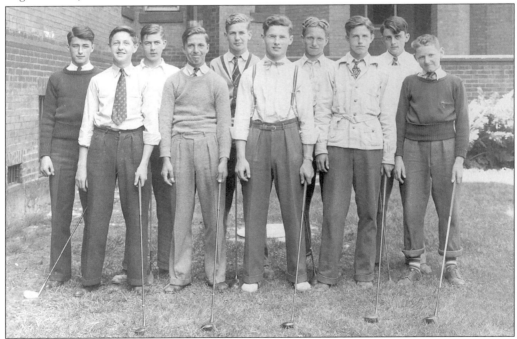

Not to be left out, a golf team was soon started at Cathedral High School. This is the 1939 team. (Courtesy of Cathedral High School.)

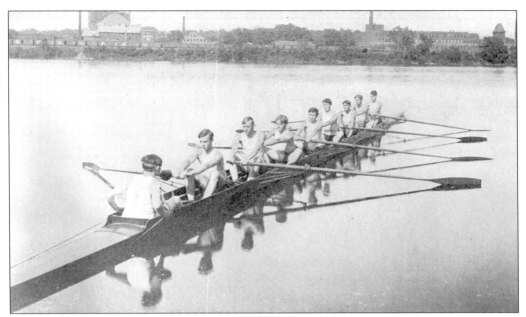

Many colleges rowed in competition on the Connecticut River in Springfield. In the 1850s, Harvard and Yale often rowed against each other on the river. Local high schools also had crew teams. In this photograph, the Springfield High School team of 1904 practices on the river. (Courtesy of Jack Hess.)

Eventually, the schools stopped using the Connecticut River to race, and the city decided to use the river for recreation. The Springfield Boat Club built a clubhouse on the river in 1913. The club later became the Springfield Yacht and Canoe Club. Other clubs came to row in events.

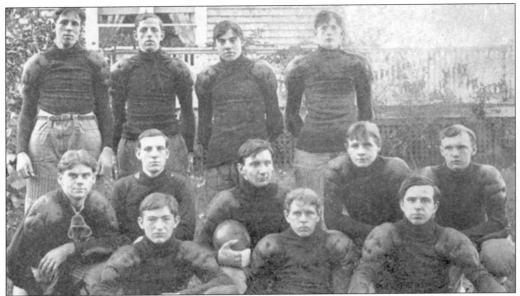

The Springfield High School football team of 1904 poses in the new and thoroughly modern uniforms of the time. (Courtesy of Jack Hess.)

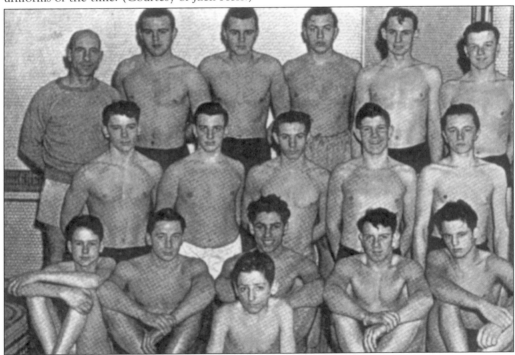

This is the 1946 swimming team of Technical High School, the Mermen. The members shown, from left to right, are as follows: (first row) R. Condren; (second row) manager R. Royce, E. Gokey, D. Kirketelos, R. Johnson, and R. Douthwright; (third row) P. Doane, D. Gordenstein, W. Sleserenka, A. Beaton, and J. Cook; (fourth row) coach Milt Orcutt, A. Rourke, J. Rourke, R. Gordenstein, H. Appleby, and J. Hamilton. (Courtesy of Springfield School Department.)

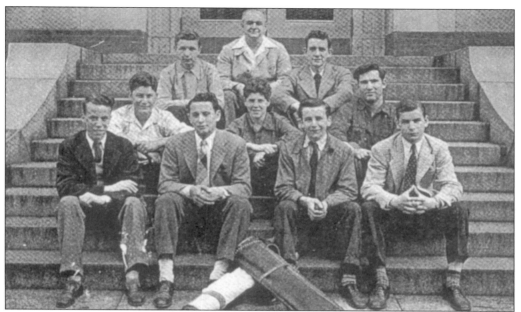

Pictured is the Technical High School golf team of 1946. From left to right, they are as follows: (front row) R. Friese, F. Moretti, D. Bonner, and W. Weise; (middle row) M. Stein, N. Rappaport, and N. Ballard; (back row) T. Marselek, "Chief" Walmer, and J. Falvey. (Courtesy of Springfield School Department.)

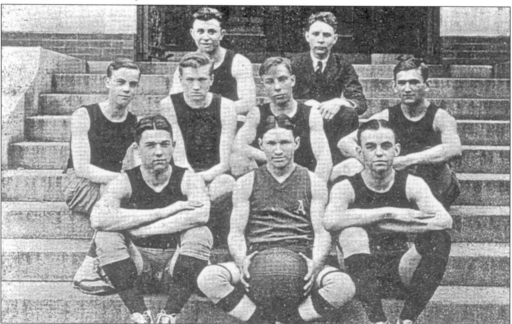

The Technical High School basketball team of 1920 won interclass basketball honors in that year. Members (in no specific order) include William Rattman, Hyman Bresky, Chester Russell, John Lyons, Max Glickman, William Costigan, and Jacob Cohen. (Courtesy of Springfield School Department.)

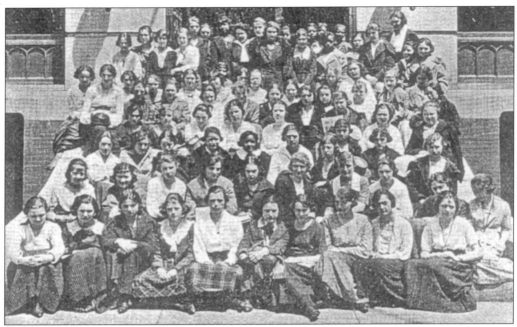

Not to be outdone, a Girls' Athletic Association began at Technical High School in 1902. The association proved to be a very popular group, as can be seen in this 1920 photograph. (Courtesy of the Springfield School Department.)

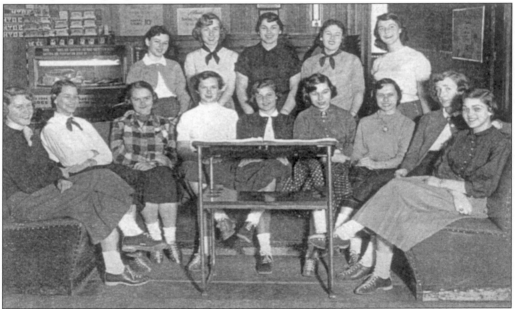

Classical High School also had boys' and girls' sports teams. This is the school's 1952 girls' bowling team. From left to right, they are as follows: (front row) Ruth Monrad, Peggy Flowers, Jane Woodworth, Ruth Krupa, Gail Canegallo, Natalie Alpert, Iris Pottern, Beverly Corliss, and Helen Hagopian; (back row) Pearl Radding, Margery Paroshinsky, Sandra Schwartz, Arlene Sitner, and Judi Bloch. (Courtesy of the Springfield School Department.)

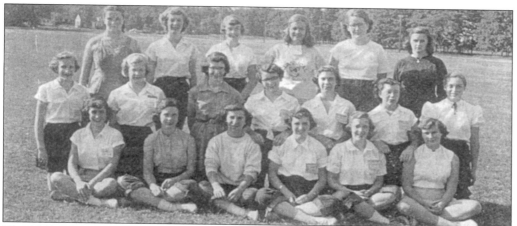

The 1952 girls' softball team of Classical High School practiced in Forest Park. Team members, from left to right, are as follows: (front row) Marilyn Beggy, Joyce Canney, Claire Falcone, Marie Callahan, Jane Chambers, and Ruth Monrad; (middle row) Janet Crozier, Lois Abbey, Ruth Lane, Judi Hall, Barbara Barton, Betty Herlihy, and Valerie Armstrong; (back row) Miss Craib, Marjory Anderson, Marijane Beltz, Phyllis Downhill, Judy Ann Skipton, and Claire Korman. (Courtesy of the Springfield School Department.)

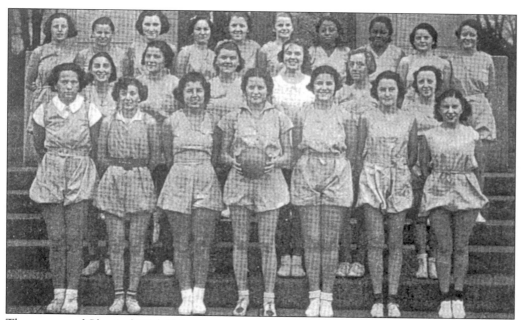

The women of Classical High School participated in every sport that was played by high school girls at the time. The 1936 soccer team members were, from left to right, as follows: (front row) Stella Homicki, Leona Deslauriers, Florence Hack, Doris Bixby, Sophie Palkowski, Hortense Allen, and Betty Jury; (middle row) Rose Derber, Suzanne Palkowski, Ruth Ryan, Doris Evon, Susan Haskell, and Virginia Steele; and (back row) Katherine Bellany, Eleanor Vassos, Barbara Cohen, Dorothy Goodman, Stella Stahura, Gwendolyn Hall, Jean Harris, Victoria Anderson, Eloise Cook, and Gene Bennett. (Courtesy of the Springfield School Department.)

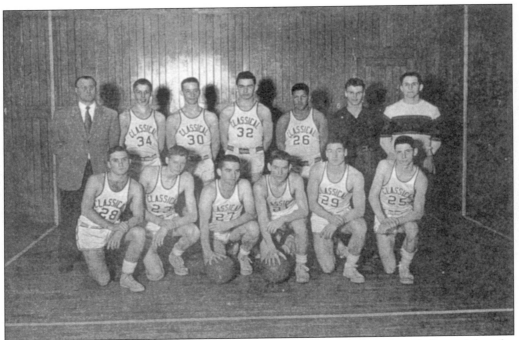

The Classical High School men's 1952 basketball team included, from left to right, the following: (front row) Jon Robarge, Edward Malachowski, Laury Shine, Charles O'Connell, Donald Hallett, and Richard Bailey; (back row) coach Joe Ambrose, William Laing, Arnold Gordenstein, Carl Sheer, Clyde Jones, and managers Brian Barry and Louis Marsella. (Courtesy of the Springfield School Department.)

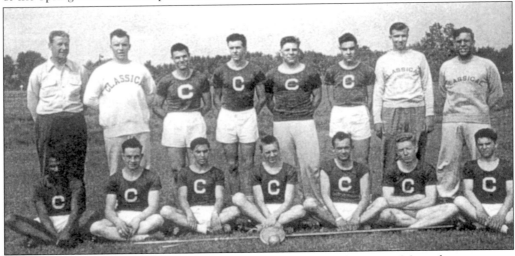

The 1951 track team of Classical High School won the coveted Western Massachusetts crown in that year. The members, from left to right, are as follows: (front row) Roosevelt Parrish, Herbert Desmond, Percy Sudsbury, Malcolm Bertram, Ralph Kerley, Edwin Rose, and Manford Roos; (back row) coach Don Vaughn, Robert Dufault, Eugene Robbins, Ronnie Magee, Joseph Mawson, Alvin Southwick, manager Robert Stetson, and Bart Kazin. (Courtesy of the Springfield School Department.)

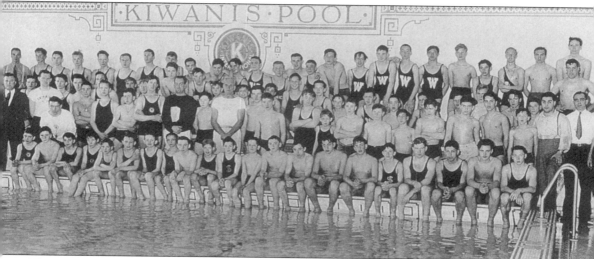

The Springfield Boys Club encouraged and taught vocational skills, along with arts and crafts and physical education. In 1925, a wing that included a basketball court, six indoor tracks, and the Kiwanis swimming pool was added to the building. This picture shows the 11th annual championship meet of 1944–1945, held at the pool. (Courtesy of the Springfield Boys Club.)

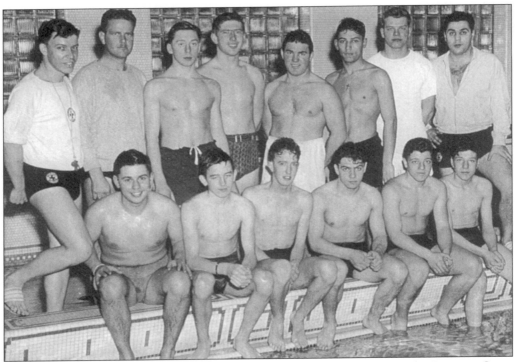

Swimming was very popular at the Springfield Boys Club. These men are the Learn to Swim Campaign instructors, *c.* 1940s. (Courtesy of the Springfield Boys Club.)

These champion swimmers of the Springfield Boys Club were entered in the competition of 1944–1945. (Courtesy of the Springfield Boys Club.)

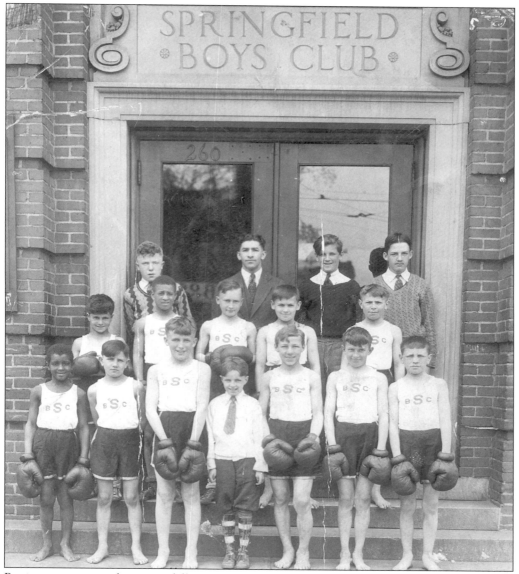

Boxing was among the many different sports taught at the Springfield Boys Club. Henry A. Wright, club president from 1989–1900, once quoted Pres. Calvin Coolidge as saying, "What the boy is the man will be." (Courtesy of the Springfield Boys Club.)

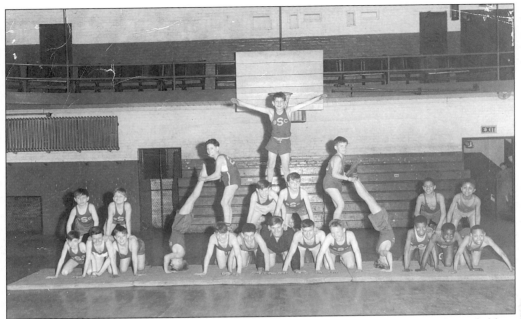

Gymnastics was yet another sport that flourished at the Springfield Boys Club. These children practice skills in the old building on Chestnut and Ferry Streets, which served the city's children for more than 58 years. (Courtesy of the Springfield Boys Club.)

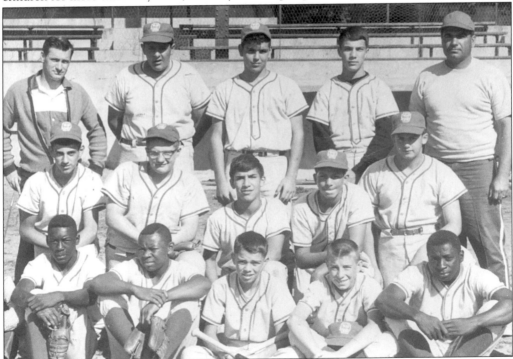

Always, there was and is baseball. This is a young team of the Springfield Boys Club sitting for a picture before a game. (Courtesy of the Springfield Boys Club.)

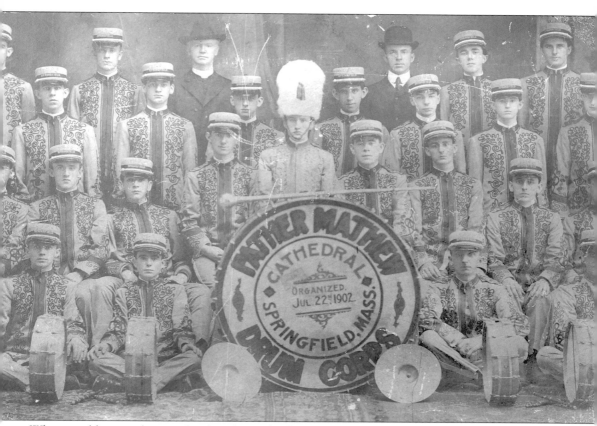

What would sports be in school without the band to cheer them on? This is the original Cathedral High School band, the Father Matthew Drum Corps, posing in 1907. (Courtesy of Cathedral High School.)

BIBLIOGRAPHY

D'Amato, Donald. *Springfield—350 Years. A Pictorial History*. Norfolk, Va.: the Donning Company, 1985.

Frisch, Michael H. *Town into City*. Cambridge: Harvard University Press, 1972.